IMAGES
of America

OAK BLUFFS
THE COTTAGE CITY YEARS
ON MARTHA'S VINEYARD

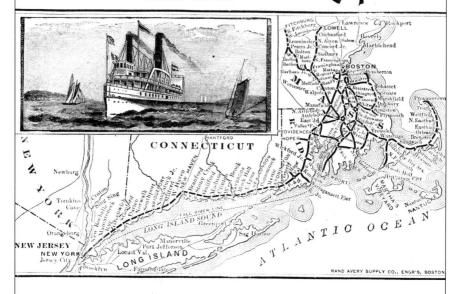

Rail connections for Cottage City were made several times a day, from all parts of New England, connecting with the steamers at Woods Hole and New Bedford. Visitors from the south and the west, coming by way of New York, used the Fall River boat, leaving New York at 5:00 p.m., making connection with the train for New Bedford and then the boat for Cottage City, arriving about 9:00 the next morning.

On the cover: Upon arrival at the Oak Bluffs resort visitors entered through the grand entranceway of the gatehouse. On the roof of the second story balcony "Oak Bluffs" was spelled out in large letters. (Author's collection.)

IMAGES
of America

OAK BLUFFS
THE COTTAGE CITY YEARS
ON MARTHA'S VINEYARD

Peter A. Jones

ARCADIA
PUBLISHING

Copyright © 2007 by Peter A. Jones
ISBN 978-0-7385-4977-4

Published by Arcadia Publishing
Charleston SC, Chicago IL, Portsmouth NH, San Francisco CA

Printed in the United States of America

Library of Congress Catalog Card Number: 2006938420

For all general information contact Arcadia Publishing at:
Telephone 843-853-2070
Fax 843-853-0044
E-mail sales@arcadiapublishing.com
For customer service and orders:
Toll-Free 1-888-313-2665

Visit us on the Internet at www.arcadiapublishing.com

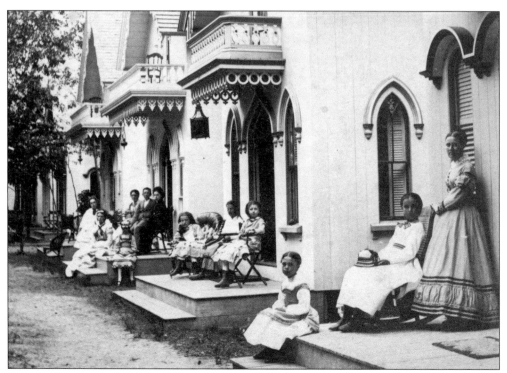

Hebron Vincent, the Wesleyan Grove secretary, looked out upon the grounds in 1867, and asked himself: "Is it a reality? Am I really in the old Wesleyan Grove or am I in some fairy-land? It must be the same place; but, O, how changed!"

CONTENTS

ACKNOWLEDGMENTS

This book is dedicated to the memory of my parents, Herbert and Evelyn Jones. The process of creating this book has given me an even greater appreciation for Oak Bluffs and the many excellent books that have been written on its history. Hebron Vincent's reports are especially significant, since they constitute the only substantial recorded history of any American camp meeting. I also wish to thank my wife Carol, my son Michael, and my daughter Debra for their advice and assistance.

INTRODUCTION

Oak Bluffs, originally known as Cottage City, is located on the island of Martha's Vineyard. The roots of Oak Bluffs can be traced to three summer communities: first, the Methodist camp meetings at Wesleyan Grove, which began in 1835; second, the resort, which was started by the Oak Bluffs Land and Wharf Company in 1866; and third, the Vineyard Highlands, which were laid out by the Vineyard Grove Company in 1868. These three communities were incorporated as Cottage City in 1880, and renamed Oak Bluffs in 1907.

The site selected for the Methodist camp meetings was located on a one-half acre oak grove near Squash Meadow Pond in the northeast section of Edgartown. The first camp meeting consisted of nine tents, which were furnished only with blankets and straw. The preachers' stand was a rough shed made from driftwood, and the congregation used plank seats. The name, Wesleyan Grove, was formally adopted in 1840, and it was renamed the Martha's Vineyard Camp Meeting Association in 1860. The camp meeting had grown to 500 tents with 12,000 people attending the "Big Sunday" services. Participants started to arrive several weeks in advance of the actual camp meeting. There was now time for recreational activities, such as ocean bathing and playing croquet in addition to attending the religious services. In 1870, the great oaks had thinned out and a mammoth tent, which was needed for protection from the sun and the rain, was placed over the seats. This canvas tabernacle was replaced by a magnificent iron tabernacle in 1879. By 1880, five hundred cottages, which were inspired by the tent frame construction, had been built by the local carpenters using a unique form of carpenter Gothic post-and-beam construction.

The year 1866 marks the beginning of an entirely new movement on Martha's Vineyard. The Oak Bluffs Land and Wharf Company was formed with the objective of developing the grounds near Wesleyan Grove as a summer resort. The company bought 75 acres of land lying between the campgrounds and the sound. The development rapidly became a watering-place for people of moderate means. Advertisements proclaimed Oak Bluffs, "the Cottage City of America." Crowds of people began to come, not only to attend the camp meeting, but to spend the entire season at the resort, while year by year more and more came for the other attractions, with no reference to the meetings at all. The resort's major hotel, the Sea View House, was considered one of the most complete and superb watering-place hotels in the world. From it, leading southward along the shore, was constructed a plank walkway. Here bathhouses and pagoda-like structures were built for rest, refreshment, and recreation. Within the development rose the beautiful Union Chapel, and hotels, one after another, as the people crowded to the area. The Martha's Vineyard Railroad was built and ran from the wharf along the beach to Edgartown and as far as Katama. Fearing irreligious contamination by the kind of people in

the resort, the Camp Meeting Association built a picket fence around the boundary of their property. The community now had two sides. On the inside were the religious fold and outside of the campgrounds were the people who came for recreation and pleasure.

The Vineyard Grove Company, an organization closely aligned but separate from the Camp Meeting Association, purchased a 300-acre tract of land in an area known as the Vineyard Highlands. It was located on the opposite side of Squash Meadow Pond from Wesleyan Grove on East Chop. In laying out this tract the company reserved a large grove for religious services, in case the Camp Meeting Association was forced to move their camp meeting site. The company quickly built a new wharf and a large hotel. A plank walkway and a horse railroad connected the new camp meeting landing to Wesleyan Grove. Lots were also sold in the new development. Speculators, realizing that East Chop was one of the best sites on the east coast, started many additional developments. However, the economy could not sustain this real estate–boom market and all of the developments ended up losing money. The Vineyard Grove Company sold the grove that had been reserved for religious services to the Baptist Vineyard Association in 1875. The Baptists erected a large wooden temple on their site, now named Wayland Grove.

The preferred landing for both the Methodists and the Baptists became the Highlands wharf. The Methodist meeting convened the week after the Baptist meeting each August. It also became apparent that both religious and secular activities could coexist. The separate communities now blended admirably in most respects into a single community. A new endeavor, the Martha's Vineyard Summer Institute, was started in the Vineyard Highlands. The institute was established for the purpose of affording teachers the opportunity of combining the study of some specialty with the rest and recreation of a seaside resort. The new town now had academic programs in addition to the religious camp meetings and the recreational activities. It was an exciting time in the Cottage City years on Martha's Vineyard.

One

WESLEYAN GROVE

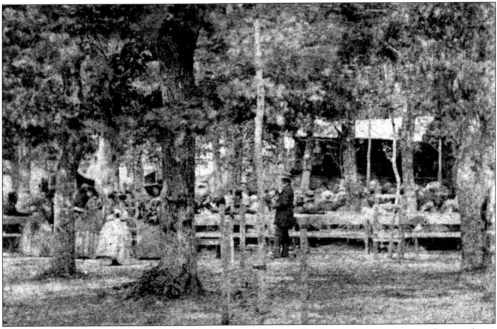

The settlement of Cottage City began in 1835 with a Methodist camp meeting in the northern section of Edgartown on the island of Martha's Vineyard. At that first camp meeting there were nine tents, a preachers' stand made from driftwood, and a few plank seats for the congregation. The site was used annually until 1844. After a year's absence, it was reclaimed in 1846 and new seats and preachers' stand were constructed to replace the original seats and stand, which had been sold. In 1856, there was discussion of moving the camp meeting because some of the oak trees were dying, but new trees were planted instead.

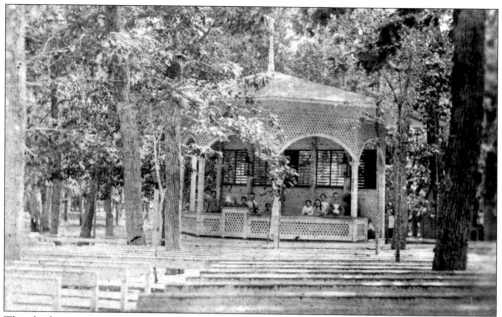

The shed was replaced by a new preachers' stand in 1859. Hebron Vincent, the camp meeting secretary, reported: "A new and beautiful stand has been erected, contrasting greatly with former ones. It is about twenty feet in length with a slightly elevated platform, a few feet in width, along the front; beyond, a large open space, or altar, enclosed by a railing, within which singers may take their positions, and anxious persons come forward for prayers."

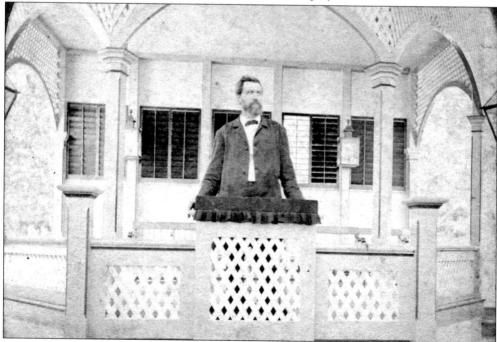

The new preachers' stand was designed by Perez Mason, an architect from Providence, Rhode Island. The stand had flat arched lattice screens supporting a roof, which was angled to act as a sounding board to magnify the speaker's voice. Movable shutters mounted on the rear wall aided ventilation.

Ministers and guests have gathered for a photograph at the preachers' stand. The bell was used to announce the hours of public service and the time for rising in the morning and retiring at night. The clock was added in the mid-1870s.

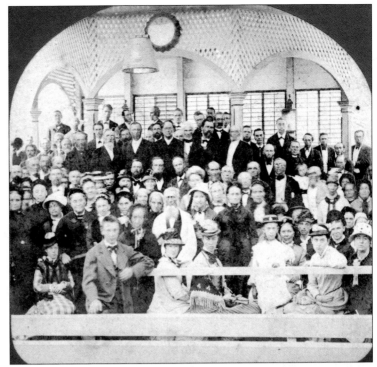

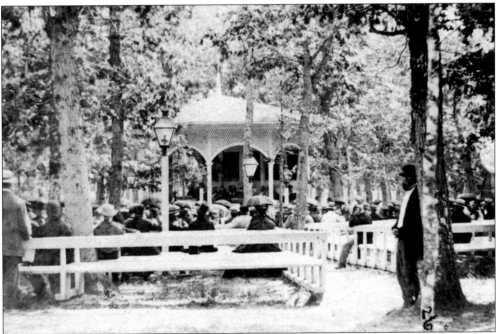

Hebron Vincent reported on the camp meeting in 1860: "The bell is rung at sunrise to call everyone from bed; again at eight o'clock, for prayer meeting in the society tents; then at ten, two, and seven, for public services at the stand. At ten o'clock at night, all persons not provided with lodgings on the ground retire, and those belonging to the ground go into their tents for the night."

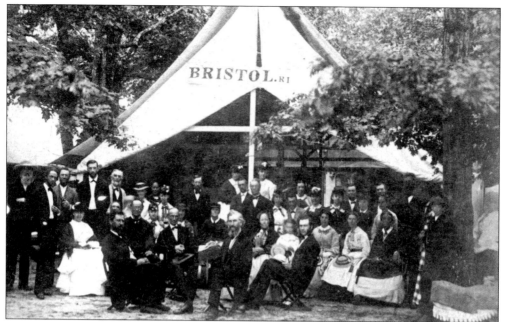

A church congregation, such as this one from Bristol, Rhode Island, maintained its own society tent. Campground rules defined the area of the society tent as sacred and gave authority to the minister of the church for everything relating to daily life. In addition to holding prayer meetings, participants also ate and slept in the society tent. A central canvas divider separated the sleeping areas for the men and the women.

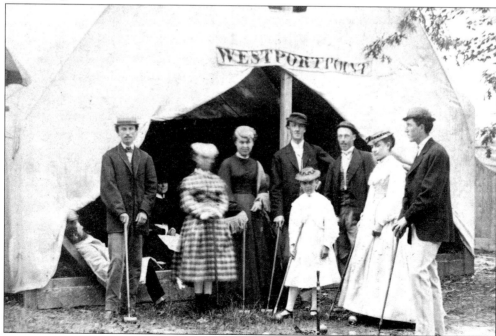

This small group from the Westport Point church found some time to play croquet during their stay on the campgrounds. There are even a few smiles as they casually pose with their croquet mallets for the photographer.

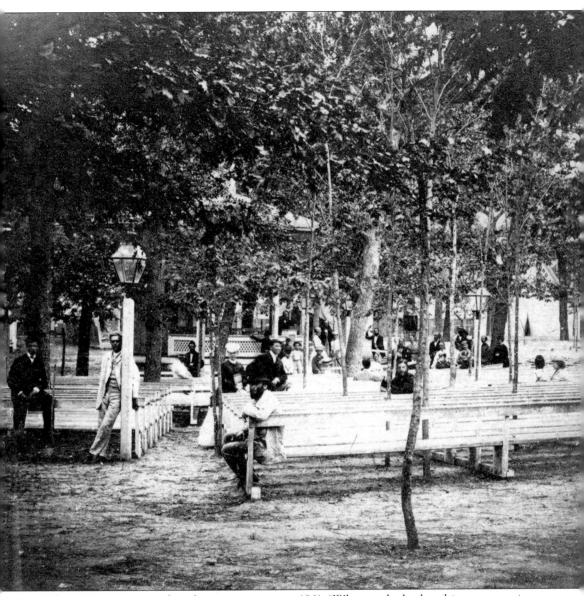

Hebron Vincent reported on the camp meeting in 1861: "Who can doubt that this camp meeting is an institution of progress? From the little cleared spot in the dense wood, with its nine rude tents in 1835, it has been enlarged, from time to time, till now it is a large circular area, sufficient to accommodate its thousands, having over forty society tents fronting upon it." A New Bedford society tent can be seen on the right side of this view.

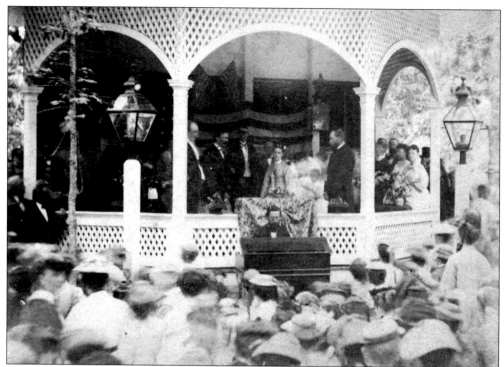

The first wedding on the campgrounds took place on August 9, 1869. It was held prior to camp meeting week with over 1,500 people in attendance to celebrate the event.

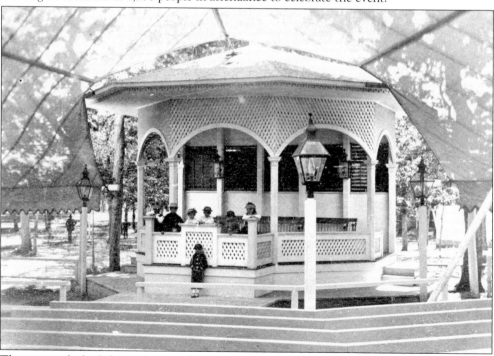

The great oaks had thinned out and a mammoth tent, which was now needed for protection from the sun and the rain, was placed over the seats in 1870.

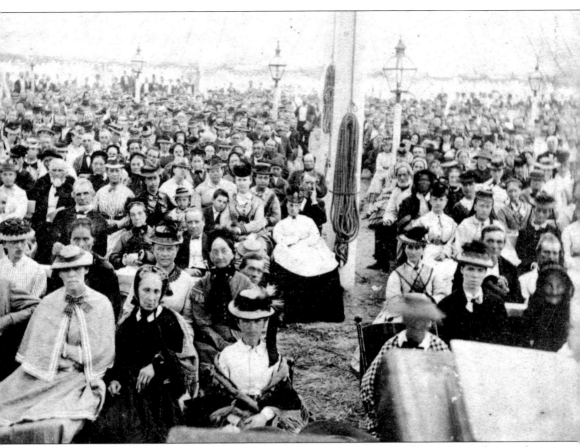

This canvas tabernacle could seat 4,000 people, but for the "Big Sunday" services thousands more found positions either sitting or standing. In 1860, there were 12,000 people at Wesleyan Grove for Big Sunday and there were as many as 36 prayer meetings going on in the society tents or outdoors.

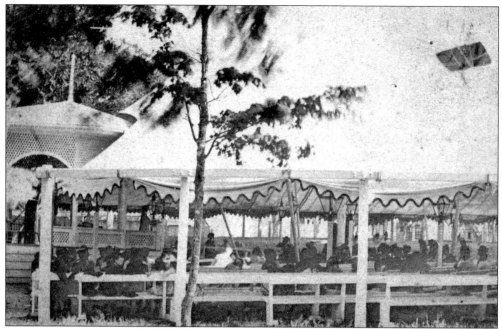

Participants in the camp meeting were never pleased with the tent and always wanted a more permanent solution. The tent had inadequate ventilation and in storms it frequently collapsed. It was also very difficult to set up and take down. At the end of the season 4,000 yards of sailcloth had to be stored for the winter.

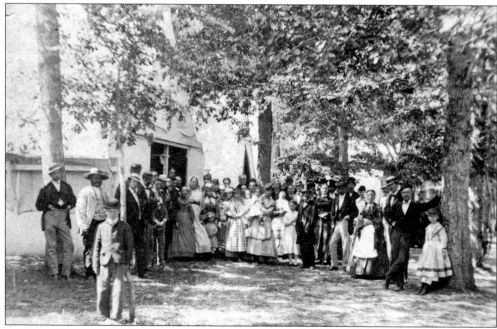

In the early years only adults attended the camp meetings at Wesleyan Grove. The first major change in the camp meeting lifestyle came with the participation of the entire family and the resulting increase in the number of family tents. There were 13 society tents in 1846 and by 1859 there were 400 tents of all kinds, including society, family, lodging, and boarding tents.

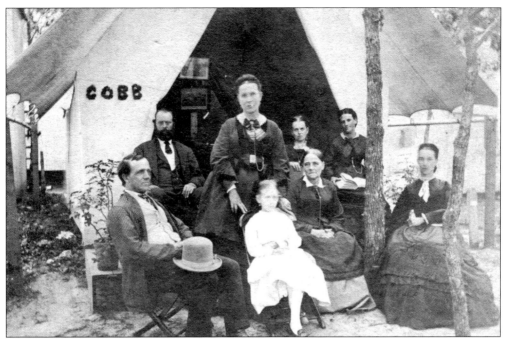

As the camp meetings became more family oriented, church members would set up their own tents near the society tent of their home church. This allowed church members wishing to be more domestic in their household affairs privacy, and a chance to enjoy an undisturbed retreat from the crowd.

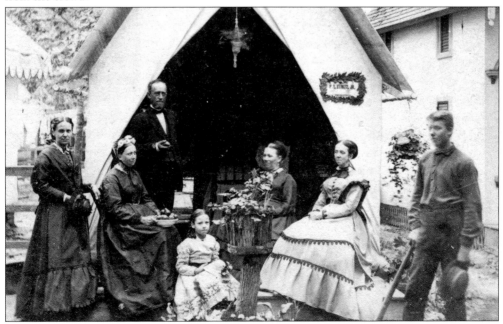

Attendance at the prayer meetings in the society tent dropped off after church members started to use their own tents. New rules were adopted to alleviate the problem. A tent could not be set up unless the owner presented a letter from his home church and later it was required that every family tent must have the name of the owner, and the name of his home church on its exterior.

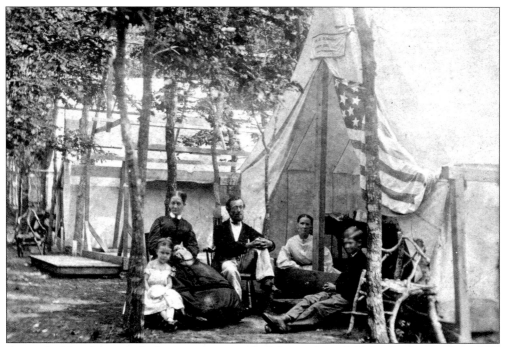

A standard family tent, which was approximately 8 feet wide and 12 feet long, cost about $50. The tent consisted of a wooden frame, floor, and a canvas covering. The owner paid ground rent from $3 to $6 a year, according to the lot location.

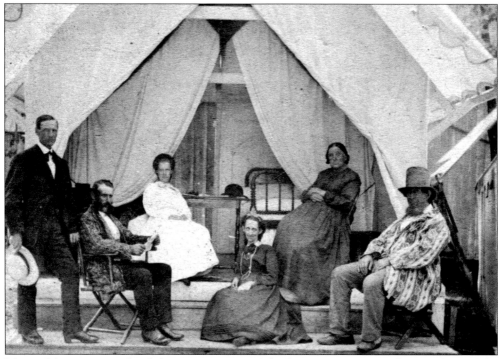

Many of the tents were divided into two sections. The front section was used as a parlor and the rear section, separated from the front section by a curtain, was used as the private area.

The furnishings in this gentleman's tent included a high quality leather rocker, a fine rug, bed with a wooden frame, several folding chairs, and a stereoscope for use between prayer meetings. An oil lamp was needed to meet the requirement that every tent, without exception, had to keep a light burning all night.

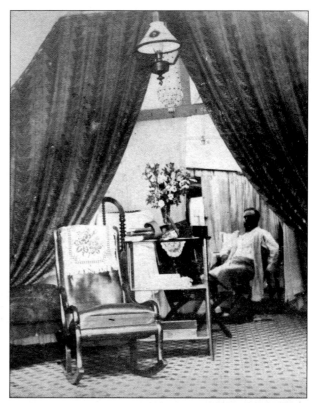

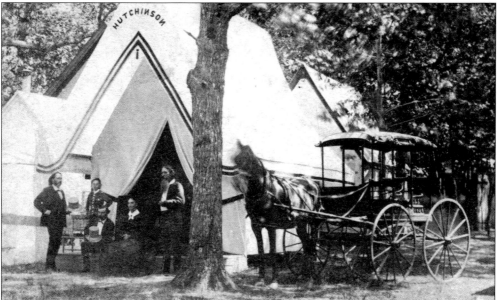

The Hutchinsons were frequent participants at the Wesleyan Grove camp meetings. They were a renowned singing family, famous for singing in remarkably close harmony and also famous for using their talent and fame to promote causes, such as antislavery, woman suffrage, temperance, and the Lincoln presidential campaign. They popularized songs such as: "The Battle Cry of Freedom," "Kingdom Coming," and "Tenting on the Old Camp Ground."

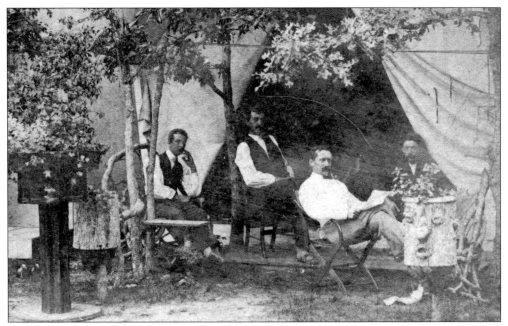

High-quality furniture, handmade stick furniture, and carved flowerpots can be seen at this lodging tent on County Park. After 1855, an increasing number of people attended and stayed a week or longer. Commercial enterprises such as lodging tents, boarding tents, barbers, and bootblacks were needed.

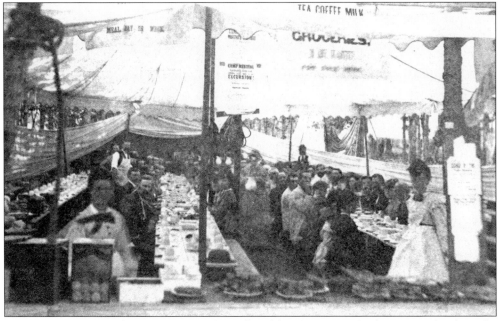

Many participants in the camp meeting brought cold provisions and others set up kitchens for cooking, but boarding tents were a popular alternative. An advertisement in 1862 stated: "Every preparation has been made for the weekly and transient boarders. Meals can be obtained at all hours of the day at short notice. The tables will be provided with all the varieties of bread, pies, cakes, puddings, roast beef, broiled steak, fried ham and eggs, and fish."

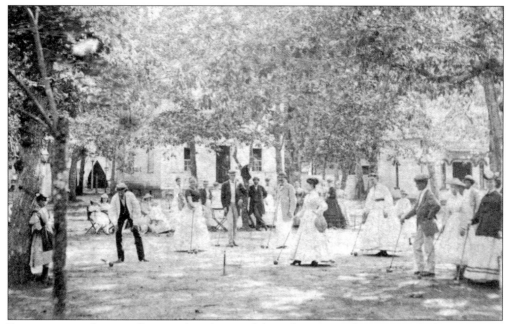

Pastimes enjoyed were walking, picking berries, fishing, boating, and croqueting. Hebron Vincent reported: "Croquet was participated in, not only by children and youth, but by large numbers of children of a larger growth, some of them gray-headed children. Even some ministers were as earnestly engaged in the game of croquet as any of the juveniles." However, all recreational activities were ordered to cease during the period of the camp meeting.

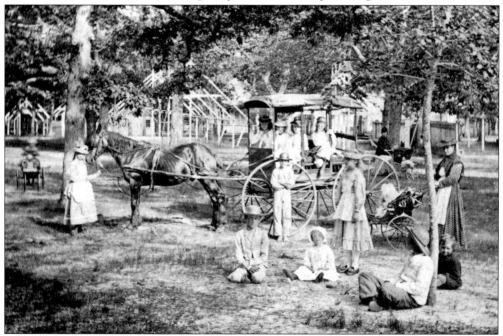

The camp meeting is over for this year and the canvas covers for the family and society tents have been stored away for the winter. However, there is still time left for a ride around the campgrounds in a horse-drawn buggy.

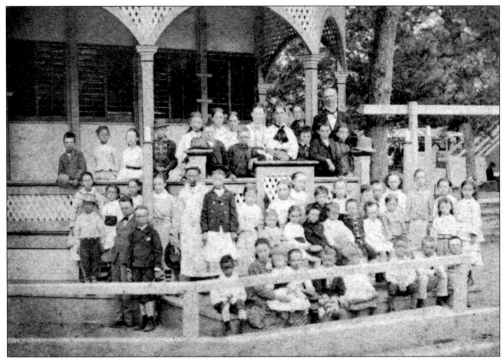

The children's preacher poses proudly with his congregation at the conclusion of the camp meeting.

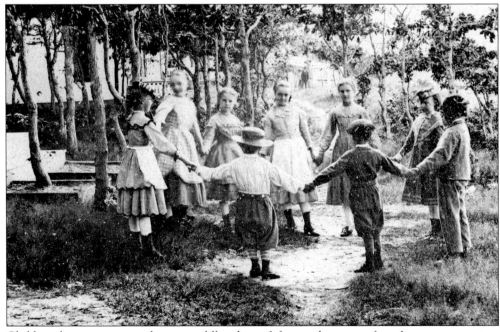

Children have come together in a fellowship of fun and games after the camp meeting. Ring-around-the-rosy was one of the many games children would play under the oak trees.

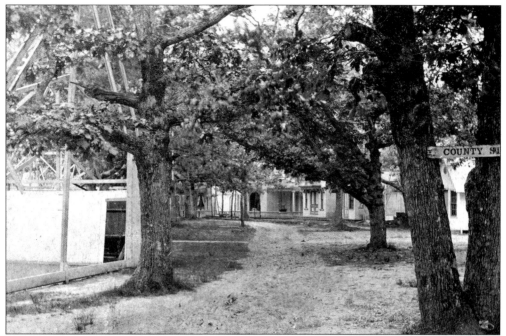

The family tents, which had been located directly behind the society tents, were moved back in 1859, clearing a 40-foot-wide avenue encompassing a circle around the preaching area. The purpose was to keep carriages and delivery wagons out of the preaching area. The avenue was first called Asbury Avenue and later Broadway.

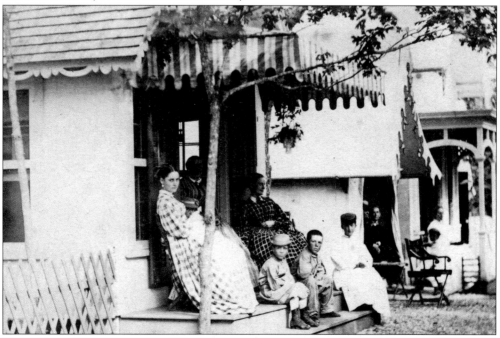

The parks and avenues, such as Fisk Avenue, were neatly laid out and by the early 1860s, lined with tents and cottages made from sailcloth, a combination of sailcloth and wood, or entirely of wood.

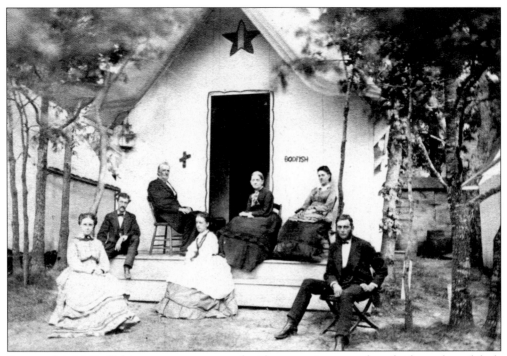

Reverend A. N. Bodfish's tent was constructed with tongue-in-groove board sides and a sailcloth cover. The vertical striations between the boards can be seen in this photograph.

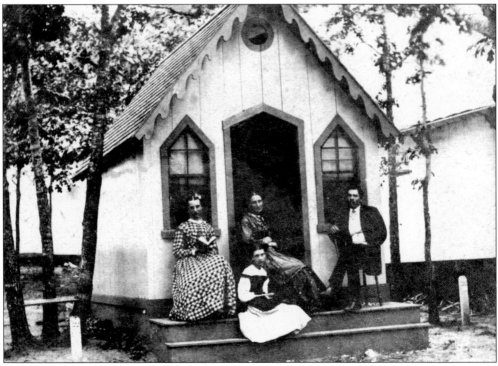

Waterproof canvas was in short supply, especially during the Civil War years. It was cheaper to cover the roof with wooden shingles instead of using canvas. The end result was a wooden tent.

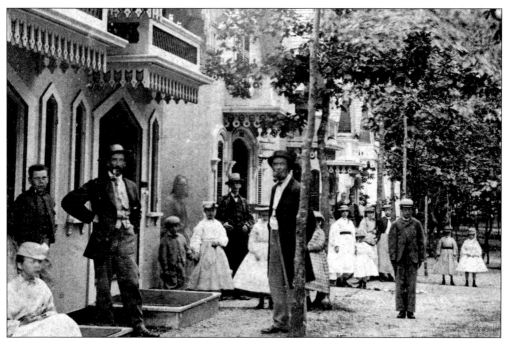

Tents with wooden roof shingles may have existed on the campgrounds as early as 1851. However, the first all wooden cottage is thought to be the Mason and Lawton cottage, shown on the left side of this photograph. Built as a two family cottage for Perez Mason and William Lawton in 1859, it was prefabricated and shipped from Warren, Rhode Island.

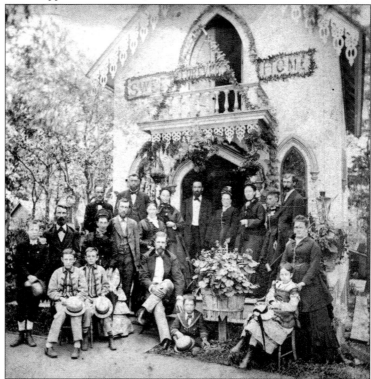

The second major change in the camp meeting lifestyle came with the increase in number of family cottages. Forty cottages went up among 500 tents in 1864. In 1868, there were 203 cottages and 330 tents, and in the following year there were 250 cottages and 300 tents.

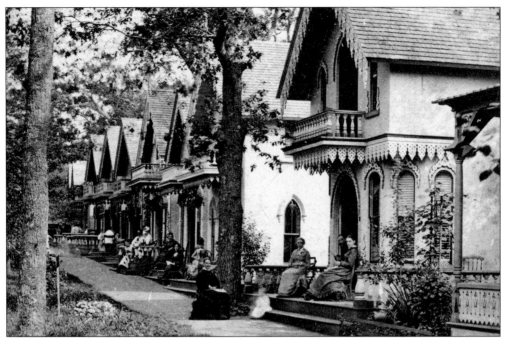

Hebron Vincent reported in 1868: "Why should more substantial houses, be thought inconsistent with the sanctities of the place? Some do, indeed, rusticate here during their summer respite, but on the camp meeting days we have a camp meeting still. Some ask: What is this place going to be? The answer is the same that it is now, only more of it."

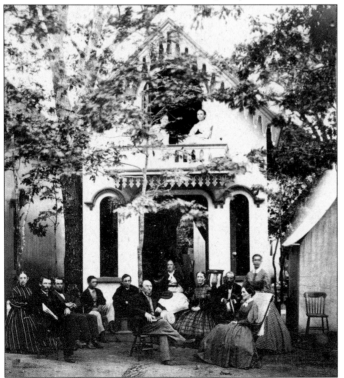

The cottage entry was a wide centered double door, which was reminiscent of both a church entry and the opening on the campground tent. On each side of the entry was a small narrow window that replicated the style of the entry. On the second story, another double door opened onto a cantilevered balcony, called the pulpit porch.

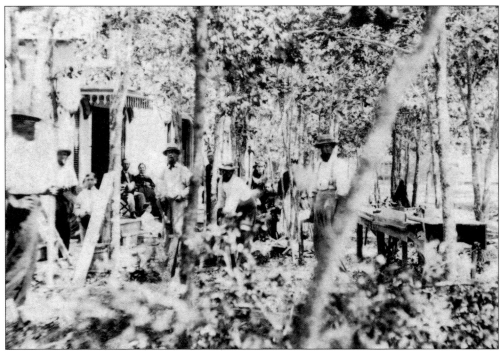

The campground carpenters were house wrights and ship wrights from many nearby towns, but the majority of them came from Edgartown and New Bedford. The unique style and construction techniques can be credited to these craftsmen.

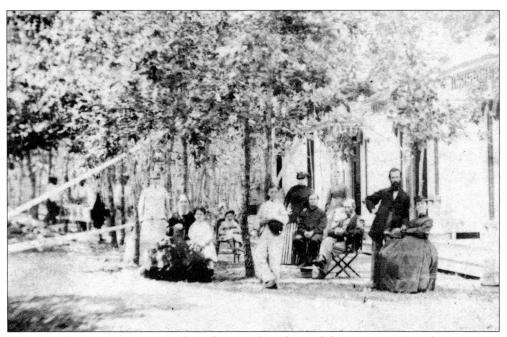

This view depicts a family posing for a photograph in front of their cottage. Note the carpenters working in the background. Hebron Vincent reported in 1866: "Sixty carpenters and painters were busy as bees, from early morn till dewy eve, erecting and beautifying these rural homes."

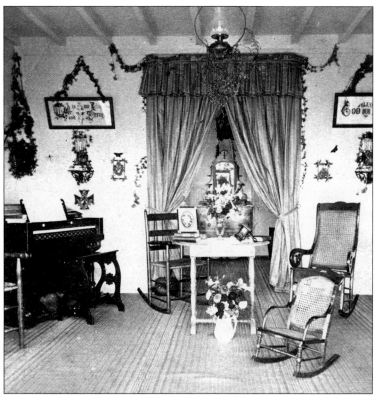

There were typically two rooms on both the first and second floors. Drapes were used in the cottage, as in the tent, to separate the front room parlor, from the more private area in the back. A steep and narrow stairway, built against a side wall, provided access to the second floor. Large upstairs furniture had to be brought in over the pulpit porch.

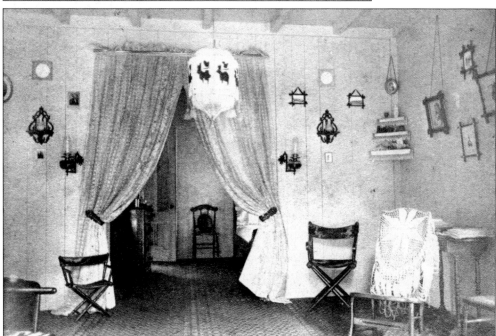

The frame of the cottage utilized post-and-beam construction with only three posts on each side wall. The beams were typically three inches by four inches thick, spaced 26 inches apart, and they extended outside on the front of the cottage to support the pulpit porch.

The walls of the cottage utilized a single layer of random-width pine boarding, which was laid vertically from the floor plate to the rafter. The boards were connected with a tongue-in-groove joint, which left vertical striations, visible from both the inside and the outside. After the walls were laid up, window and door openings were cut out and then the prefabricated windows and doors were installed. The final step of the assembly was the installation of the gingerbread trim.

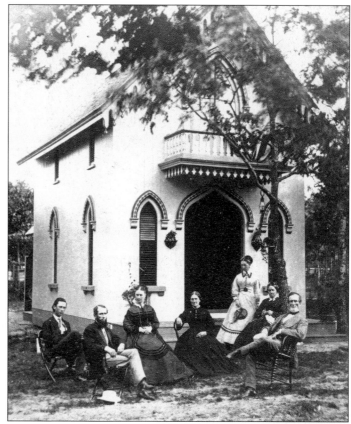

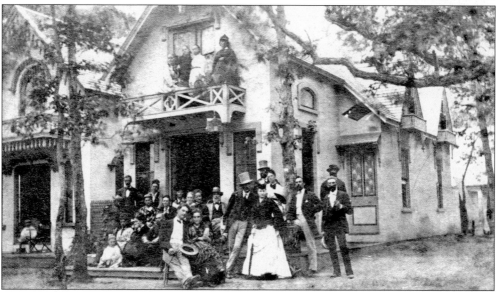

The Romanesque round arch and the Gothic pointed arch were the most popular styles for door and window openings. However, there were also cottages with variants, such as the flat opening shown on this cottage. A cottage modification, such as a side addition, could easily be made by the removal of the tongue-in-groove boards on a side wall.

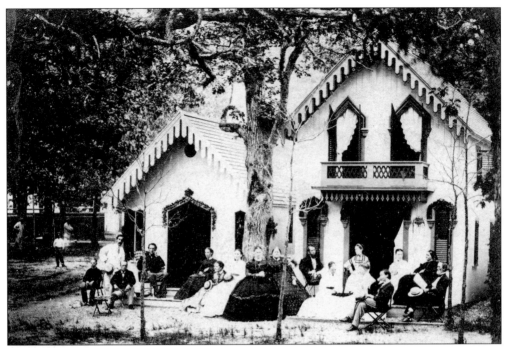

There were also a few single-story cottages on the campgrounds. Note that both of these cottages use a straight side variant of a pointed arch for the door and window openings. The two-story cottage has two doors on the second floor instead of the more common single centered door.

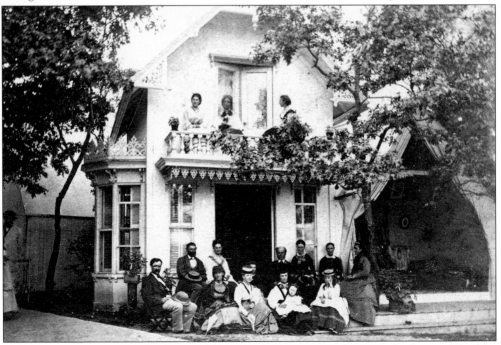

This family's campground residence includes both a cottage and an attached tent. The tent utilizes tongue-in-groove boards on the side walls and a canvas covering. The parlor in the tent is well furnished and open in the traditional campground style.

The campground cottages were more alike than they were different, but it was the gingerbread trim that gave each cottage its individuality. This cottage had distinctive hood moldings around the windows and doors. It also had distinguishing verge board on the roof and brackets on the pulpit porch.

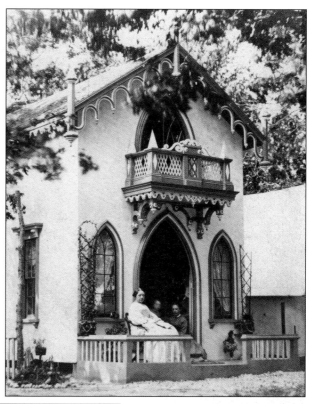

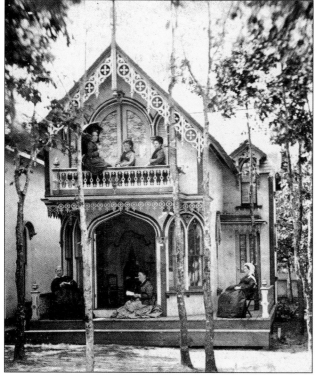

This cottage is not only noteworthy for its flamboyant gingerbread trim but also for its construction. The front wall on the first floor had curved corners. The posts had been removed with the result that the tongue-in-groove wall boards on the first floor, also functioned as the supporting structure for the second floor.

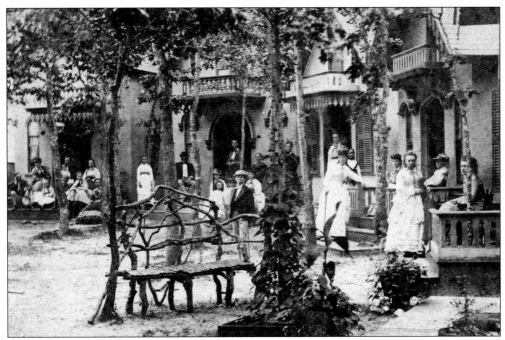

This view shows cottages on Forest Circle. Note the handmade settee and the community atmosphere in this small neighborhood on the campgrounds.

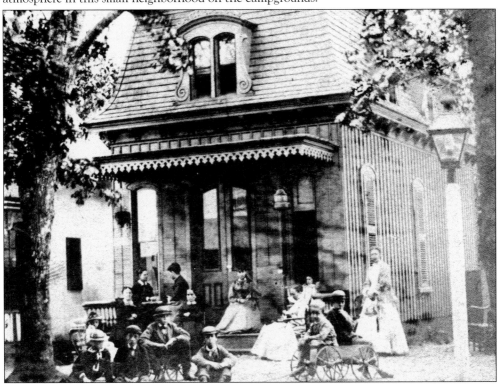

Several of cottages on the campgrounds had mansard-style roofs, which provided additional space on the second floor. A cottage of this style cost between $1,200 and $1,500.

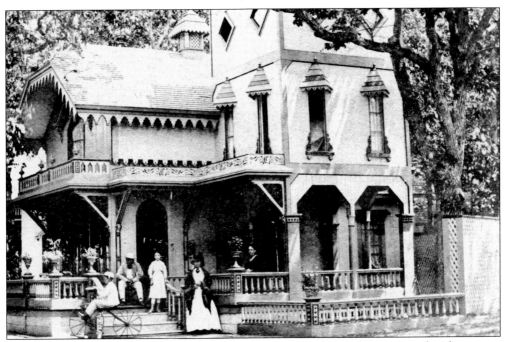

This view shows the Clark cottage on Broadway. It was one of several cottages with a three-story tower. The cottage was later moved to Pequot Avenue in the Oak Bluffs development. The young man is riding a two-wheeled velocipede, the predecessor of the bicycle.

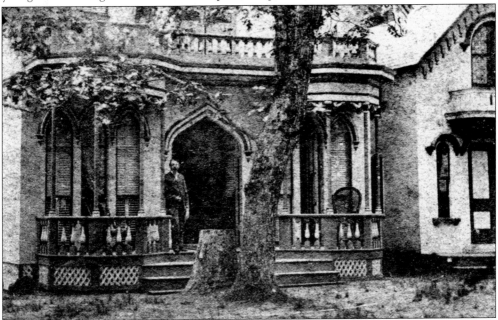

The most expensive cottage on the campgrounds was built in 1869 for William Sprague, at a cost of $3,500. Elected governor of Rhode Island in 1859, Sprague was among the first to respond to Lincoln's call for troops and fought valiantly in the Battle of Bull Run. Sprague resigned as governor in 1863 to become a U.S. senator. That same year, he married Kate Chase, daughter of Secretary of the Treasury Salmon P. Chase (later chief justice).

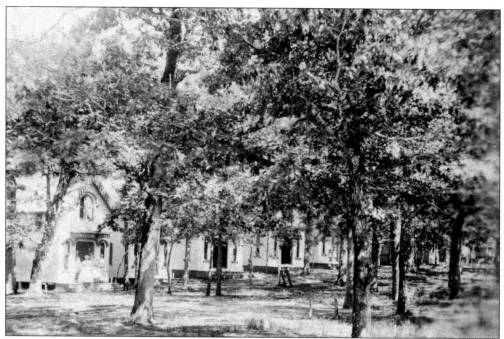

The majority of the cottages were relatively inexpensive, costing $150 to $600, and quick to build, going up in less than three days. The cottages were also highly portable. Since the cottage was not constrained by a foundation or utilities, and the lot was leased annually, an owner could easily move his cottage to another location. In some cases, cottages were moved several times on the campgrounds or moved off the campgrounds to the Oak Bluffs or Vineyard Highlands developments, where the lots were for sale.

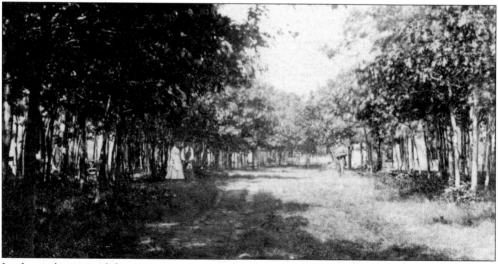

In the early years of the camp meetings the main entrance was a path at the southern end of the campgrounds. The steamers from Providence and New Bedford landed at Norris wharf in Eastville, on the east side of Holmes Hole. After landing, participants walked or rode wagons eastward for nearly a mile along a sandy trail. After bypassing the wetlands of Squash Meadow Pond, they entered the campgrounds from the south, as shown in this view. This path was later named Clinton Avenue in 1868.

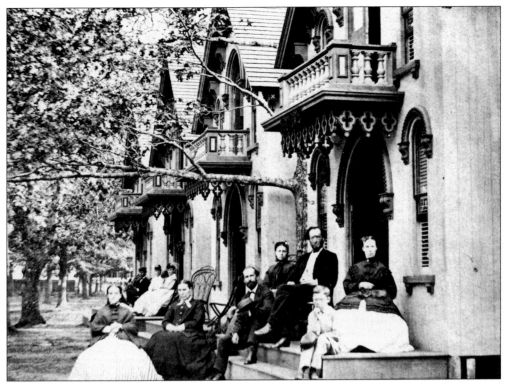

Four cottages were built on the east side of Clinton Avenue in 1868, by men from Brooklyn, New York. These "New York" cottages were magnificently furnished and the cottages had distinctive brackets on the roofs, and a round arch hood molding with a chain motif detail over the doors and windows.

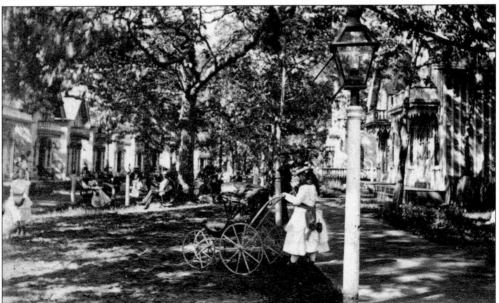

In 1869, the Clinton Avenue entrance was closed to carriages. Sidewalks were installed on both sides of the avenue. Note that whale-oil streetlights were used on the campgrounds at night.

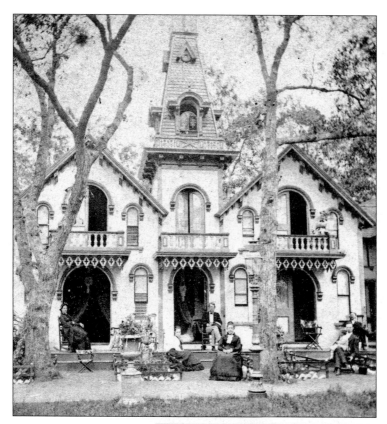

Two of the "New York" cottages on Clinton Avenue were combined into a single cottage in 1872 by Joseph Spinney, a retired sea captain from Great Neck, New York. The whale-oil streetlights on Clinton Avenue were replaced with petroleum-oil streetlights at that time. The lamps were mounted on wood turned posts, which were similar in size and form to those in the streets of Brooklyn, New York. One of these lampposts can be seen in this photograph.

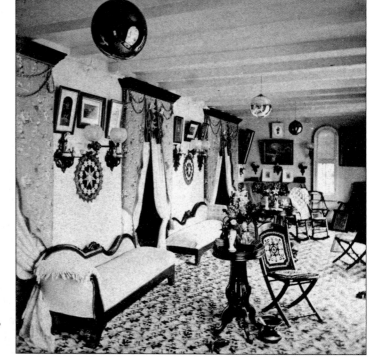

The Spinney cottage had three entries to the front-room parlor. Curtains separated the parlor from three private areas in the back. Note the elaborate furnishings, including a spittoon for the gentlemen.

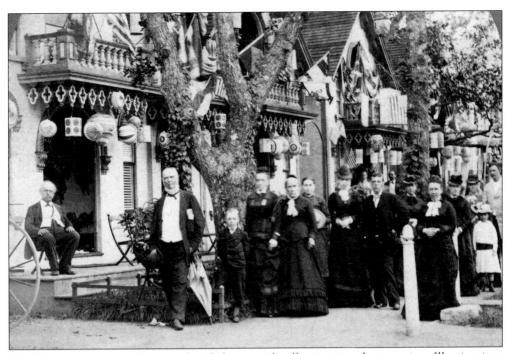

The Spinney cottage is decorated with lanterns for illumination that evening. Illuminations started in the Oak Bluffs development, but evolved into a campground tradition. This illumination celebrated the visit of Pres. Ulysses S. Grant.

A crowd of 30,000 people came to see the president of the United States in 1874. A gala celebration was held with fireworks, a marching band, and a parade of carriages. The president stayed at Bishop Gilbert Haven's cottage on Clinton Avenue. The presidential party consisted of Grant and his wife, Gen. Babcock (Grant's private secretary) and his wife, Miss Campbell (Mrs. Babcock's sister), and Miss Barnes.

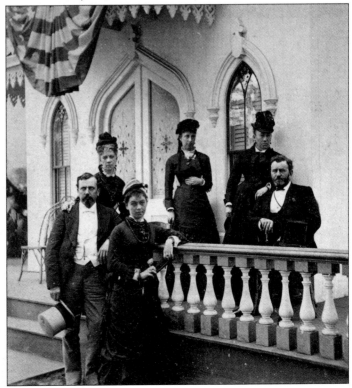

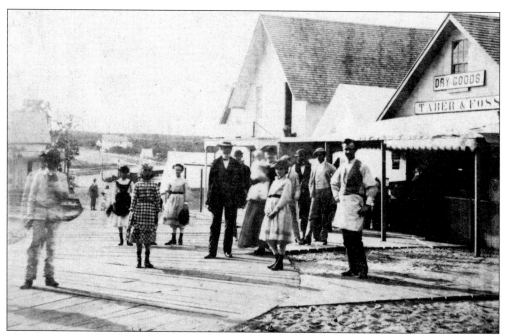

This view shows Domestic Square, around 1871. Starting in 1869, camp meeting participants landed at a new wharf in the Vineyard Highlands and entered the campgrounds at Domestic Square. All the essential goods and services for the participants' stay were provided by the commercial businesses on the campgrounds.

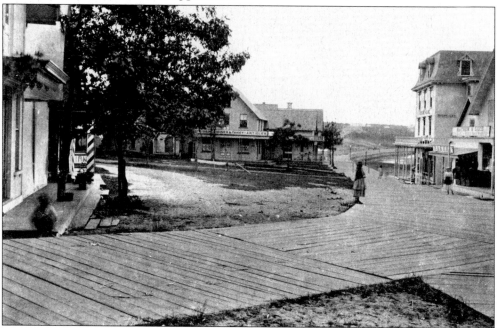

This view shows Commonwealth Square, formerly Domestic Square, around 1875. The plank walkway, from Commonwealth Square to the camp meeting landing, can be seen in the background. The entrance to Fourth Street Avenue and the entrance to County Street Park can be seen in the foreground.

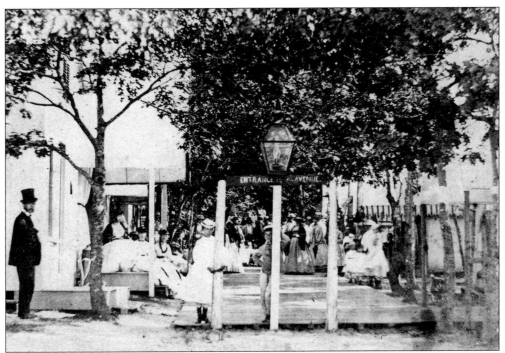

Fourth Street Avenue was named for the Fourth Street Methodist Church in New Bedford. Broadway can be seen in the background.

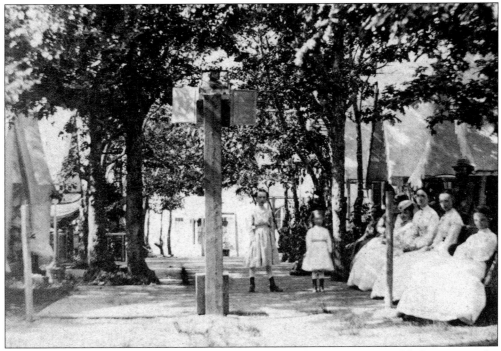

This view shows Fourth Street Avenue as seen from Broadway. Commonwealth Square is in the background. The residents of Fourth Street Avenue were said to be the most pleasant people around because they continued to live in the primitive camp meeting architecture.

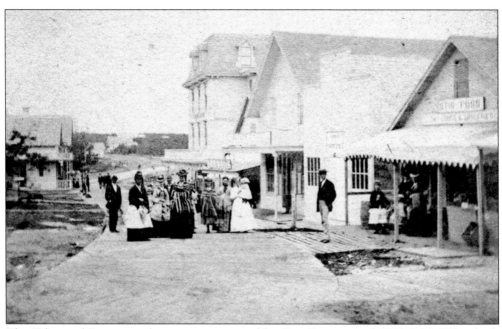

The Taber and Foss general store is now owned by Otis Foss, around 1875. J. M. Taber built another store on Circuit Avenue. In the background, on the left side can be seen Dr. Leach's pharmacy, office of the Hatch Express Company, and Vineyard Grove Post Office. In 1879, the *Cottage City Star* was located in the post office building. The newspaper advocated the secession from Edgartown. In the background, on the right side can be seen the Howard House.

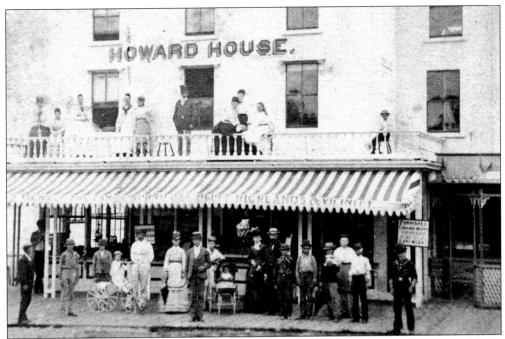

The Howard House had a restaurant on the first floor, which had an excellent view of Lake Anthony and the Vineyard Highlands. The photography studio of Joseph Warren was located next to the restaurant. Note the sign on the awning: "Views of the Campground, Oak Bluff, Highlands & Vicinity."

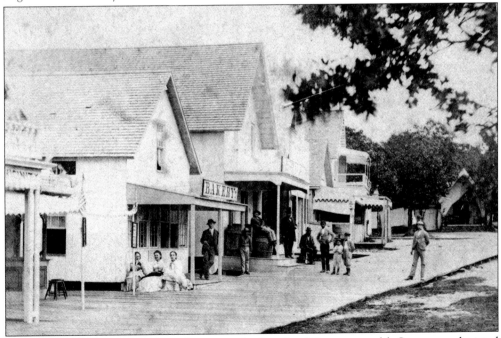

The commercial businesses along the upper plank walk of Commonwealth Square are depicted in this view around 1875. Joseph Warren's photography studio, a bakery, Mayhew and Luce hardware store, and Otis Foss's general store were located here.

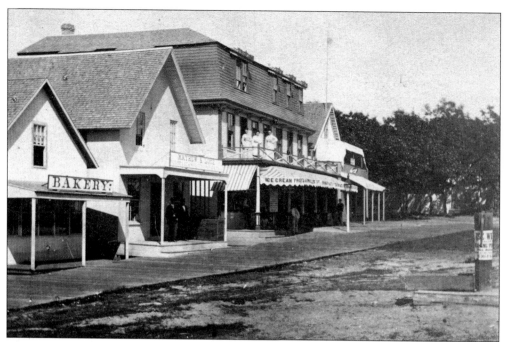

The commercial businesses along the upper plank walk of Commonwealth Square are depicted in this view around 1878. The Wesley House was built on the site of Otis Foss's general store. Note that there is a new well at the center of Commonwealth Square.

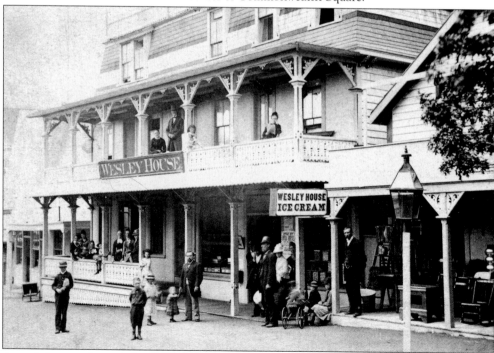

A roofed-in porch, with highly decorative gingerbread trim has been added onto the second story of the Wesley House, around 1880. Note the fine furniture, which was available in the store next door and the poster, which advertises for the opera house.

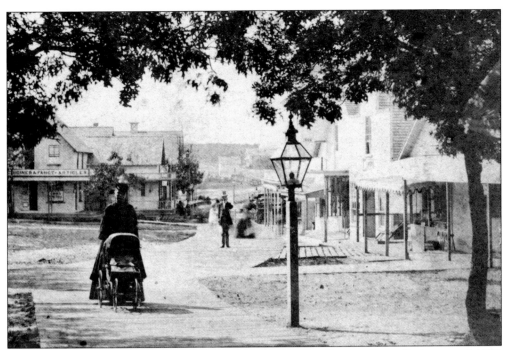

This view shows a young lady pushing a baby carriage into County Street Park, around 1875. In the background is Dr. William Leach's pharmacy. The sign indicates that his store carried medicines and fancy articles. It also had a soda fountain.

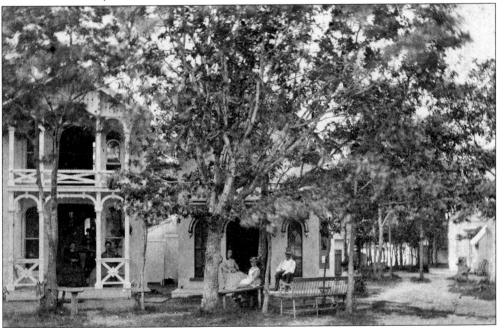

An area on the campgrounds, originally known as "the prairie," was laid out in 1865 into a small circular park, called County Street Park and later County Park. The residents were from the County Street Methodist Church in New Bedford. Note the cottage with the unusual roofed-in porches, on the left side of this view. The path on the right led to Lake Anthony.

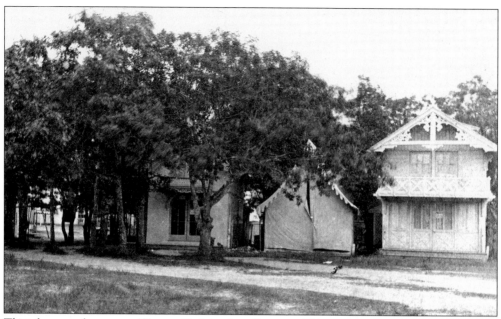

This photograph captures County Park in the off-season. The entrance to Montgomery Square from County Park can be seen on the left. The cottage on the right was nicknamed the Swiss Chalet. Note that the owner of the tent has decided not to store the canvas covering for the winter.

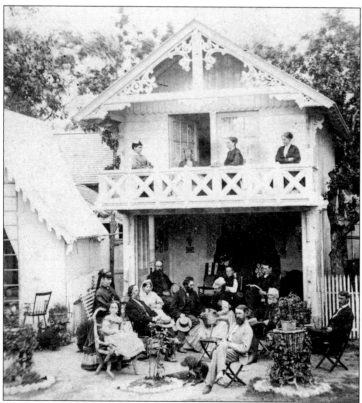

The Swiss Chalet acquired its nickname from its distinctive architectural style and the gingerbread trim. The cottage had been prefabricated in New Bedford and installed on County Park in 1868. Note that the entire front wall on the first floor could be opened.

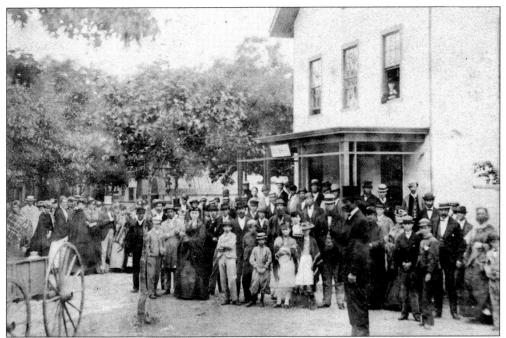

The Dunbar House was erected in 1866, on the former site of Dunbar's boarding tent on Montgomery Square. The two and a half story building had 31 rooms for rent. It was the largest permanent commercial building on the campgrounds.

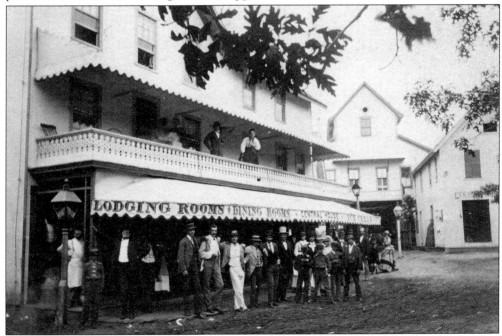

The Dunbar House was renamed the Central House in 1870. Lodging was increased to 60 rooms. In the background of this view are the Arcade and grocery store of A. R. Gifford. The Arcade had shops, lodging, and office space. It also served as the gateway between the Oak Bluffs resort and the campgrounds.

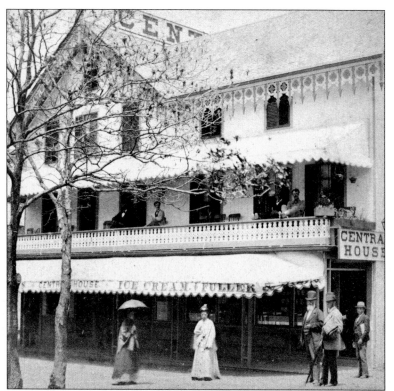

The Central House, under proprietor J. S. Fuller, was recognized as having the best accommodations on the campgrounds. Pres. Ulysses S. Grant dined at the Central House during his visit in 1874. All of the hotels provided the popular treat, ice cream.

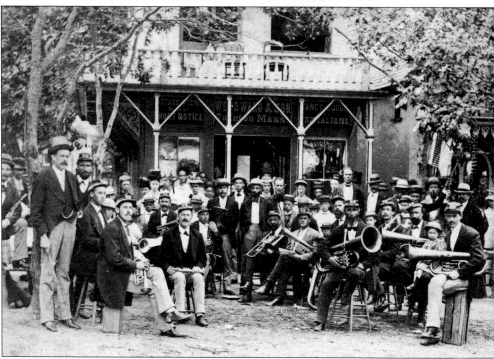

The photography studio of Woodward and Son was located directly opposite the Central House. Off-island bands were sponsored by the local hotels.

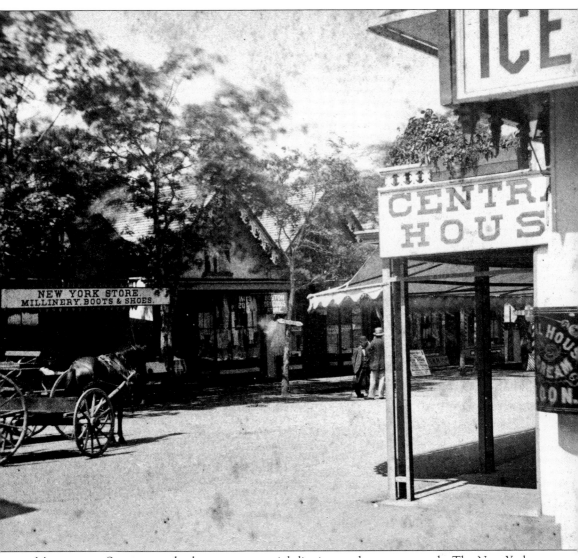

Montgomery Square was the largest commercial district on the campgrounds. The New York Store, Boston Dry Goods Store, restaurant, book store, and barber shop can be seen in this view, around 1880. The photograph was taken by Richard Shute from in front of his summer gallery.

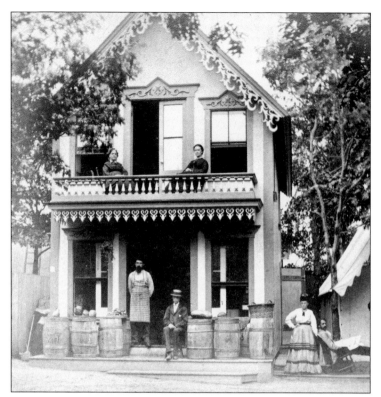

The cottage of Moses W. Chadwick was located behind the Central House on Central Avenue. Chadwick, a New Bedford merchant, operated a grocery store for the summer months on the first floor of his cottage.

The Methodist Chapel was built in 1878 for the year-round residents of the local community, which was known at that time as Vineyard Grove. It had been planned for the chapel to be located on the site of the preachers' stand. However, it was located instead within the row of society tents that fronted the preaching area. A society tent can be seen on the right side of this view.

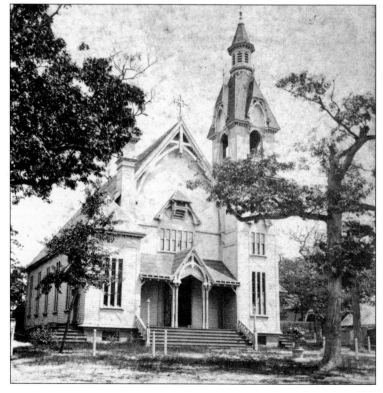

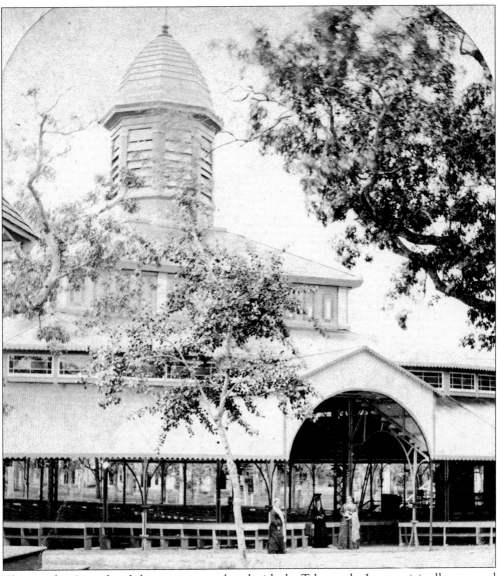

The preachers' stand and the tent were replaced with the Tabernacle. It was originally proposed that a wooden tabernacle be built. However, the resulting bids were too high and campground cottager, J. W. Hoyt was awarded a contract on April 25, 1879, for an iron tabernacle. On July 26, 1879, the first religious service in the Tabernacle was held with 800 people in attendance.

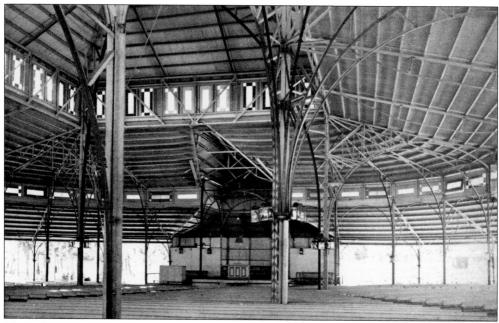

The Tabernacle was made from pre-fabricated wrought iron, the most innovative architectural technology of the 19th century. Four iron supports were placed 40 feet apart and they arched in toward the center, meeting 75 feet above the floor. Five arches fan out from each of these creating 20 major supports. Since it was built on uneven ground it needed to be flexible, and the iron pieces were connected with wooden joints. The Tabernacle was described in an 1880 travel book as a "kind of religious crystal palace, though made of iron."

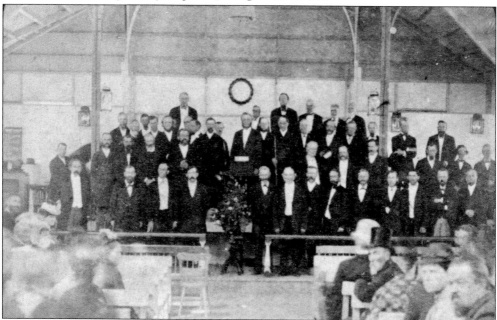

In 1835, Wesleyan Grove had nine tents and a preachers' stand that was made from driftwood. By 1880, the Martha's Vineyard Camp Meeting Association had grown to 110 tents, 500 cottages, and the Tabernacle.

Two

OAK BLUFFS

The Oak Bluffs Land and Wharf Company was formed in 1866 with the objective of developing the grounds near Wesleyan Grove as a summer resort. About $10,000 was expended in laying out lots, avenues and parks, and building a wharf in that year and a storehouse in the following year. The development plan included provisions for 10 parks, with the largest Ocean Park. Erastus Carpenter, the lead promoter, wanted the first view for the visitors to see as they approached Oak Bluffs to be Ocean Park, framed by impressive cottages.

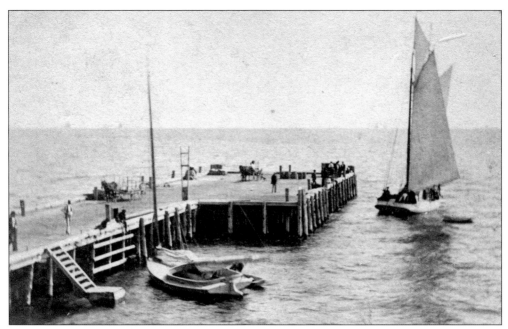

The wharf for Wesleyan Grove had been located on the east side of Holmes Hole, in relatively protected waters, but the Oak Bluffs wharf was the first to be built directly into Vineyard Sound. Many islanders thought that it would not survive the winter. However, it did survive, and in 1868, it was increased in length from 240 feet to 320 feet.

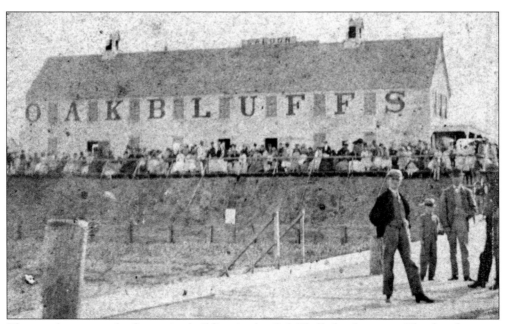

The storehouse was the first major building in the Oak Bluffs development. The first floor was used as a storage facility, dining saloon, and company sales office. The building also served as the first hotel in the Oak Bluffs development with the second floor being used for lodging.

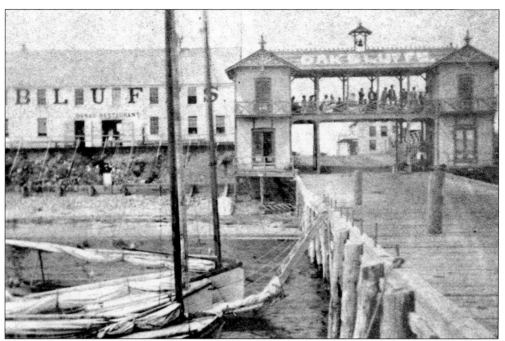

A gatehouse at the head of the wharf was built in 1868. On the roof of the second-story balcony, "Oak Bluffs" was spelled out in large letters. Visitors would pass through this grand entranceway into the new resort.

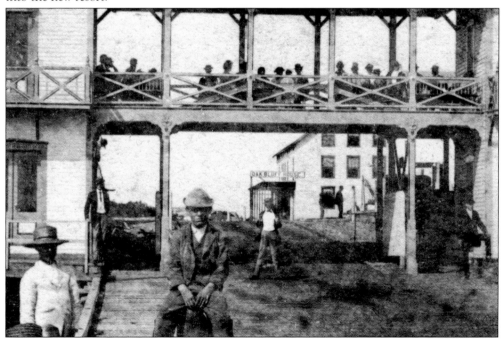

The first significant hotel, the Oak Bluffs House, was located behind the gatehouse. It was completed in 1869. It should be noted that the sign on the building reads "Oak Bluff House." It was later devoted to other uses, having been superseded by many newer hotels and rooming houses.

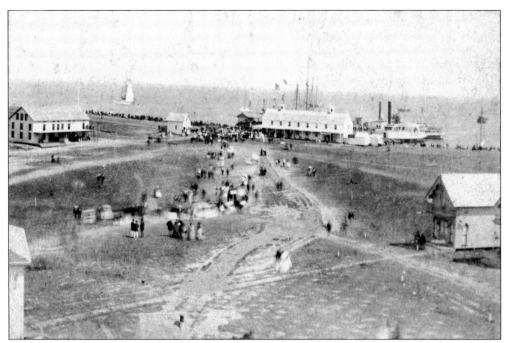

The Oak Bluffs landing was photographed in 1870 from the recently opened Pawnee House. The promoters of the resort would later boast of the concreted streets, but visitors had to walk on sandy paths when the development first opened.

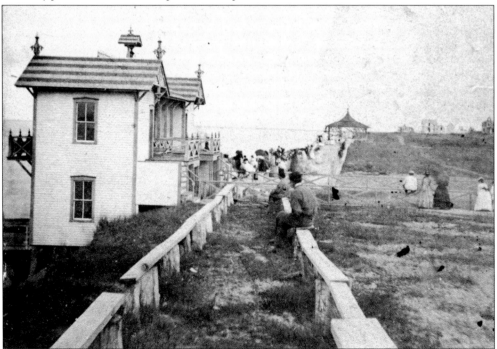

The storehouse, the first company building, was removed in 1870. It was cut into two sections and reassembled on Circuit Avenue. At the top of the bluffs, a 15 foot wide plank walk was built. By the summer of 1871, it had extended one-half mile southward from the wharf.

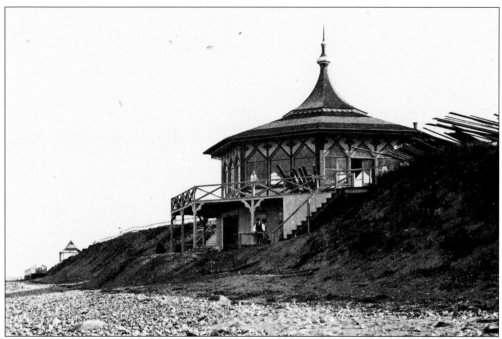

An octagonal pavilion, or pagoda, as it was called at the time, was built a few hundred feet from the wharf on the plank walk. Carpenters can be seen in this view constructing a stairway to the beach. The bath arbor pavilion and the bathhouses are in the background.

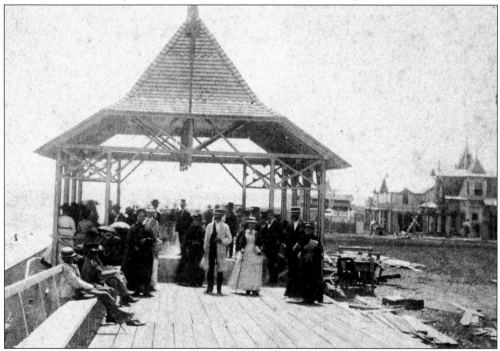

The bath arbor pavilion and the cottage of William Claflin, governor of Massachusetts, can be seen nearing completion in this view. The arrival of Claflin at his cottage became a major event. A crowd greeted the governor at the wharf and walked with him to the gubernatorial cottage.

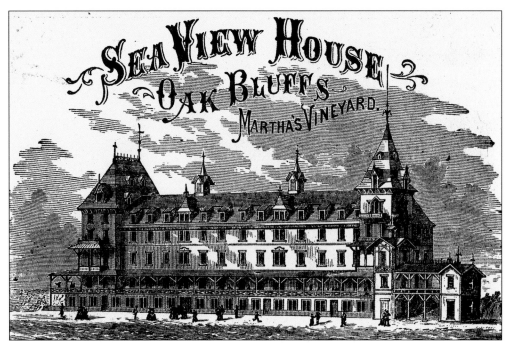

The Sea View House was erected on the former site of the first company building and opened for business on July 23, 1872. It was considered one of the most complete watering-place hotels in the world. Advertisements emphasized that its facilities for boating, fishing, and bathing were unsurpassed, and that it had the finest location of any summer house on the coast.

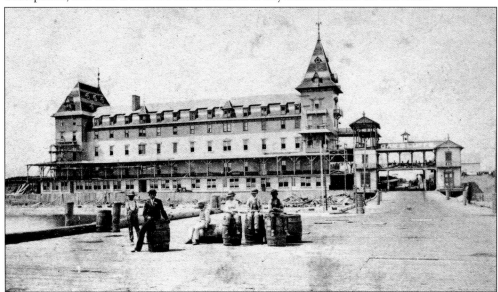

The Sea View House, built at a cost of $102,000 with an additional $30,000 for furnishings, transformed the whole character of the community. It had 125 well-furnished lodging rooms with accommodations for 400 guests, separate parlors for the ladies and the gentlemen, and a billiard room in the basement with six tables. The lodging rooms on the European plan cost $1 a day during July and $2 a day during August. On the American plan, the rate in August started at $4 a day.

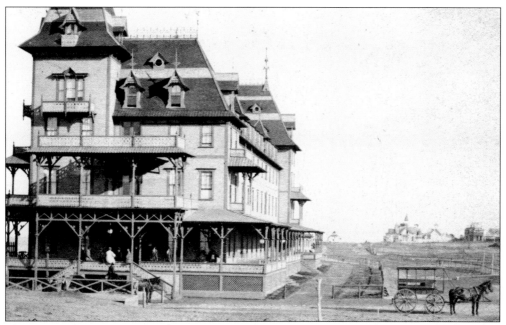

The Sea View House was five stories high on the ocean side and four stories high on the inland side. The gatehouse connected at the north end of the building, where there was a tower, 100 feet high, rising above the roof of the central part of the hotel, and then sharpening into a spire with a flagstaff rising to 126 feet. At the south end of the building rose another tower 85 feet high with a steeply pitched roof. Note the omnibus awaiting passengers.

An omnibus is dropping passengers off at the Sea View House, the center of the Oak Bluffs social scene. In the background is a second omnibus waiting to pick up passengers, as it makes its way around Ocean Park.

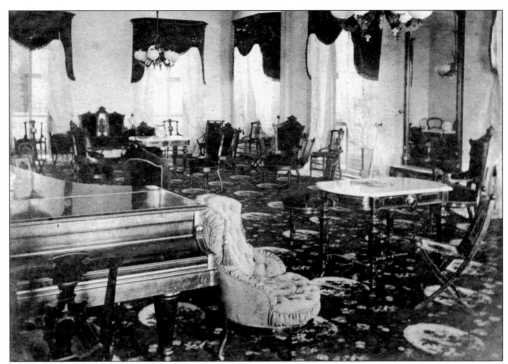

The staircases and a steam elevator in the Sea View House were finished in black walnut and chestnut, and only the best English tapestry carpeted the hallways and parlors. The gentlemen's parlor, which was furnished with plush upholstery, is shown in this view. A reception for Pres. Ulysses S. Grant was held in this parlor in 1874.

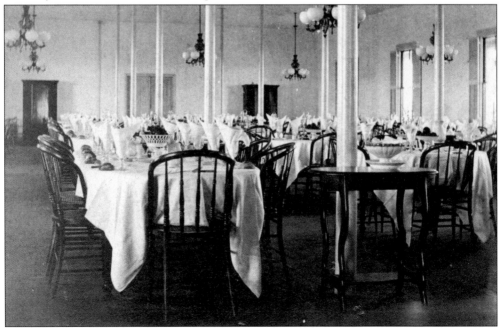

The dining hall was the largest of five dining rooms, which had a total capacity to serve 400 people at the same time. The entire hotel was lighted by gas.

This is a view of the north bluff, as seen from the Sea View House, around 1873. In the background is Lake Anthony and the Vineyard Highlands. A barrier beach separated Lake Anthony from the ocean.

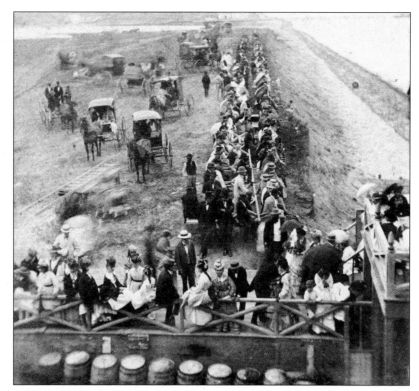

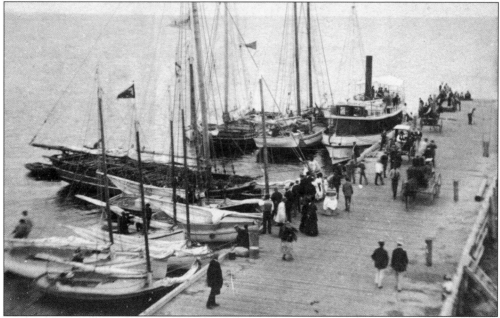

Oak Bluffs had a busy landing for commercial and pleasure boats. The diminutive steamer at the end of the wharf is the *Helen Augusta*. This screw driven propeller vessel was purchased by the Martha's Vineyard Steamboat Company in 1865. It was now being used to supplement the larger paddle wheel steamers. Boating was one of the many activities in the new resort. Sailing and fishing yachts could be chartered at the wharf.

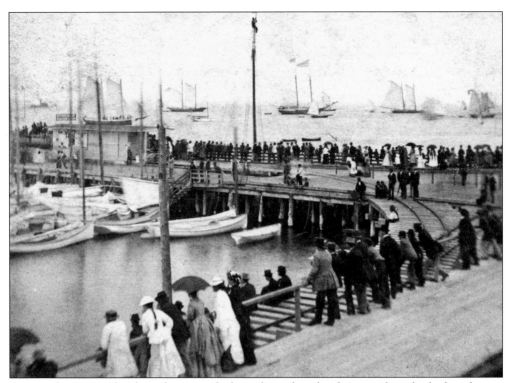

Regatta day in 1875 has brought a crowd of people to the wharf. A man has climbed to the top of a ship's mast for a better view.

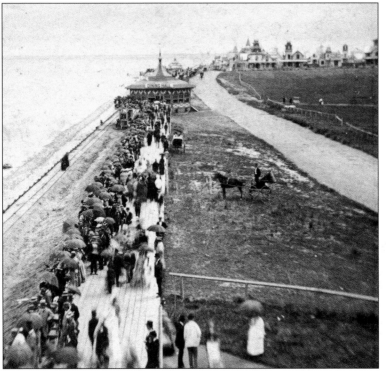

This is a view of the south bluff, as seen from the Sea View House, around 1875. Promenading on the bluffs was one of the most popular activities in the new resort. Visitors, dressed in their finest clothes, could stop at the pagoda for refreshments or continue on further to the bath arbor and go ocean bathing.

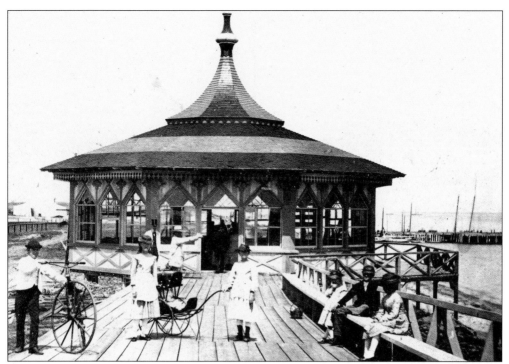

The pagoda, a refreshment stand, was conveniently located on the plank walk. Its octagonal shaped counter was located at the center of the building. Promenaders could sit at tables and enjoy the view out over the ocean.

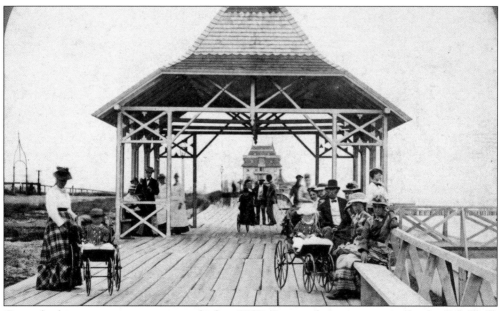

Ocean bathing was a new pastime in the late 1860s. It was a feature attraction for the Oak Bluffs resort. The bath arbor, a prominent pavilion on the plank walk, was the entranceway to the bathhouses and the beach.

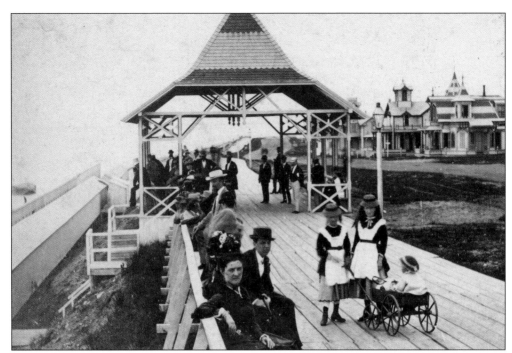

The staircase from the bath arbor to the bathhouses can be seen in this view. The large rock on the beach was nicknamed Lover's Rock. Spectators came to watch the bathers, as well as the ever changing panorama of nautical vessels passing by.

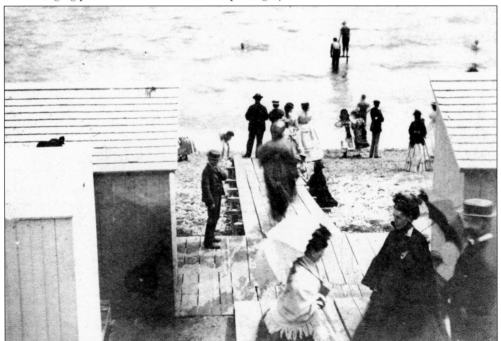

Bathers were dressed in their finest clothes when they walked to the bath arbor. It was considered a breach of etiquette to be seen in bathing attire outside the beach area. Therefore, they changed into their bathing clothes in the bathhouses.

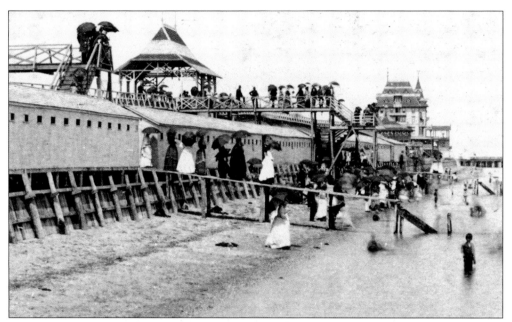

A bathhouse was a small enclosure with a window on the back wall providing the only light and ventilation. The daily rent was 5¢. Note that sunbathing was not in fashion at that time and the well-dressed ladies are still completely covered on the beach.

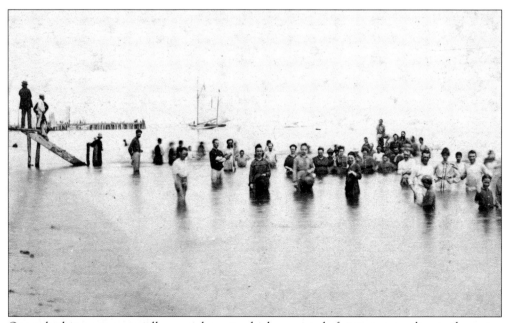

Ocean bathing was essentially a social event, which consisted of sitting or standing in the water, and talking to the other bathers. Participants went bathing from about 10:00 a.m. to noon every day except on Sunday. After bathing, the clothes were rinsed in a tub with fresh water and then hung up to dry for use the next day.

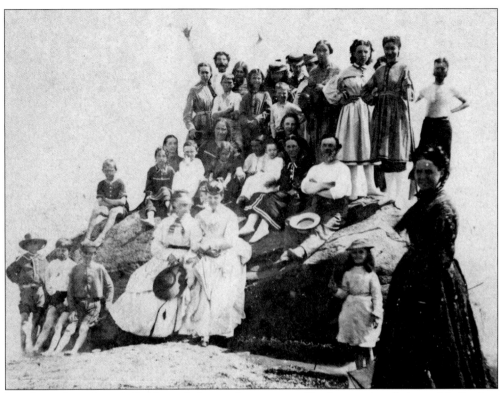

It is low tide at Lover's Rock, and this smiling group of bathers and well-dressed ladies has gathered for a photograph.

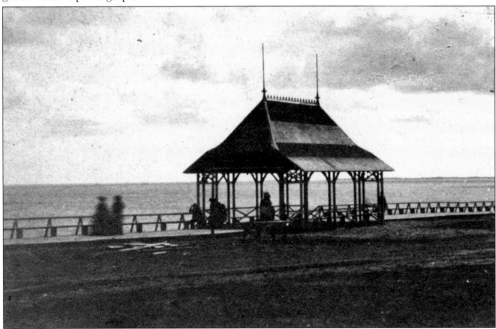

Promenading on the plank walk to the bath arbor in the early evening, and possibly being left stranded on Lover's Rock at high tide, was also a popular Oak Bluffs pastime.

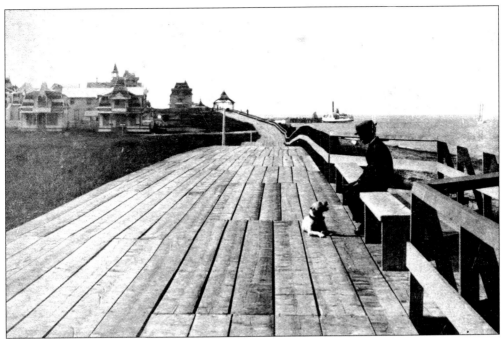

Advertisements proclaimed: "Home by the Seaside, Oak Bluffs, a new summer resort, one thousand lots for sale, cheap and quiet homes by the sea shore during the summer months."

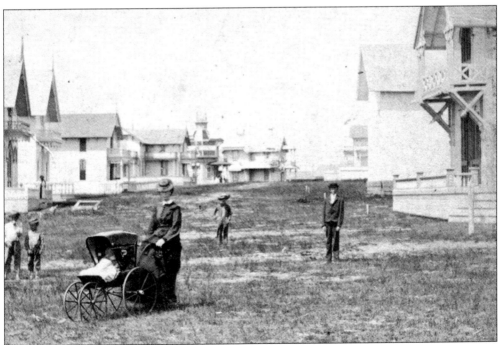

The price range for a lot was from $100 to $400 and most of the cottages were offered for sale in the price range from $750 to $4,000. The showpiece cottages were much higher in price. By 1869, 300 lots had been sold and 60 cottages were built.

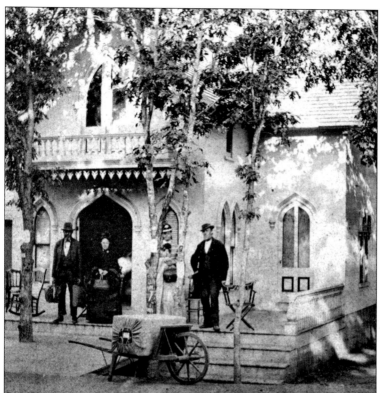

The Gothic arch, shown on this Kennebec Avenue cottage, was the most popular style used in the Oak Bluffs development. Most of the cottages were similar in design to those in Wesleyan Grove, and they were built by many of the same carpenters. However, the lot sizes were larger than on the campgrounds, and the cottages tended to be larger.

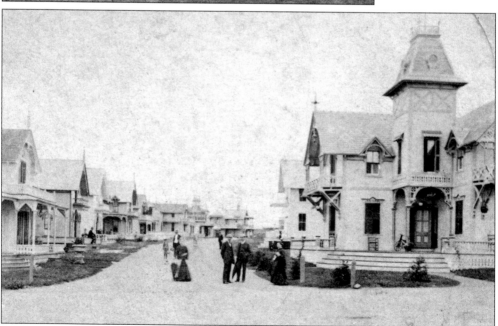

This view shows Narragansett Avenue at the intersection of Sea View Avenue. Many of the cottages in the development, such as the one on the right, utilized one or two campground-style cottages as the fundamental building block. A more elaborate cottage was formed by adding balconies, dormers, and a tower.

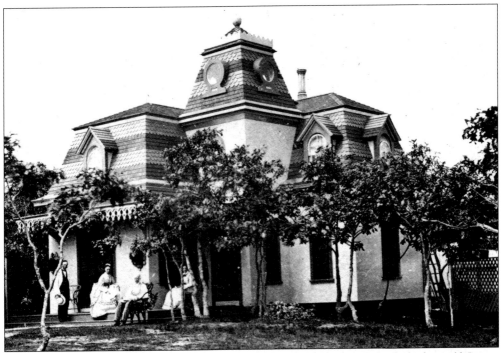

Erastus Carpenter, the lead promoter, had one of the earliest cottages built for himself. It was built in 1868, at a cost of $12,000.

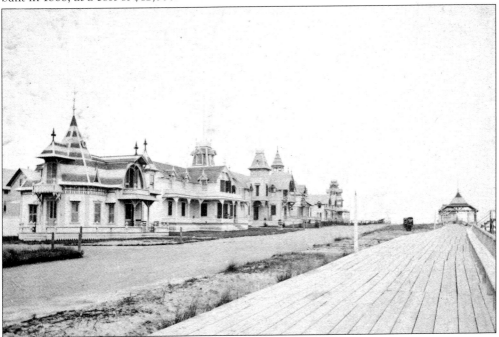

The lots and cottages on Sea View Avenue and Ocean Avenue were sold to gentlemen that Erastus Carpenter knew would share his vision for Oak Bluffs. Sea View Avenue, shown in this view, was lined with the cottages of William Claflin, John Medina, Hiram Blood, Theodore Tillinghast, and Albert Barnes.

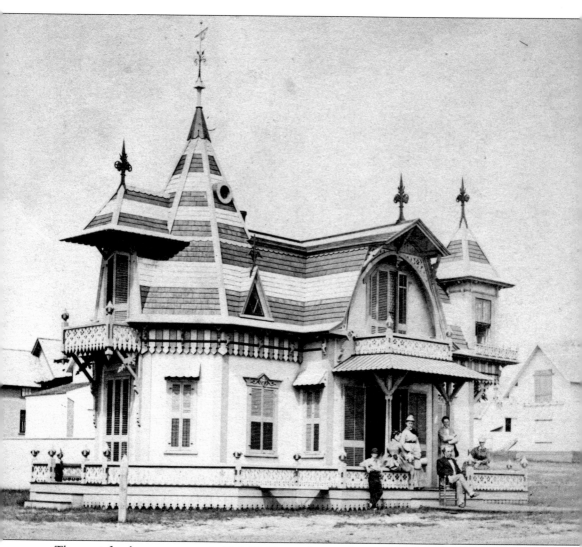

The most flamboyant cottage in Oak Bluffs was the one designed by architect Samuel Freeman Pratt for William Claflin, the governor of Massachusetts. While governor, Claflin promoted women's suffrage and prison reform. He also was a frequent participant at Wesleyan Grove and presided over many of the camp meetings. Pratt had been hired by the Oak Bluffs Land and Wharf Company to design many of the distinctive buildings that gave the resort its unique character. These included the Sea View House, Arcade, Union Chapel, pagoda, and bath arbor.

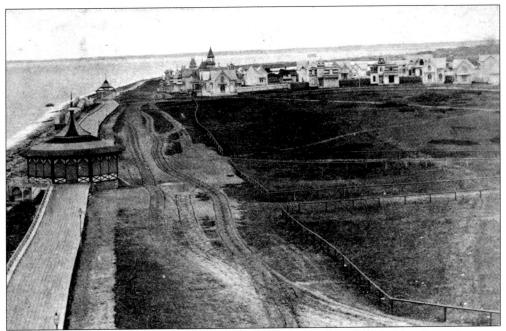

This view from the Sea View House overlooks Ocean Park around 1873. A road to Edgartown had been built along the beach and Sengekontacket Pond in 1872. Prior to that time, residents of Edgartown had to travel inland or by boat to attend the camp meetings or the Oak Bluffs resort.

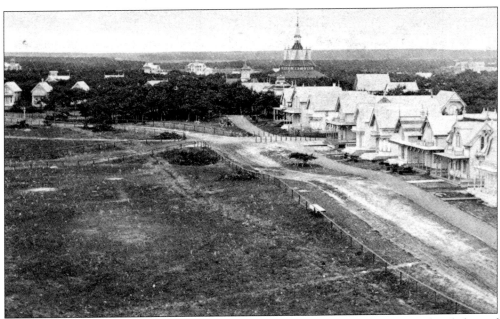

The Union Chapel, with its three-tiered roof and octagonal spire, dominates the skyline of Ocean Park, as seen from the Sea View House. Ocean Park was the premier site in the Oak Bluffs development. The cottages around Ocean Park on Ocean Avenue had the best views of Vineyard Sound, and the Sea View House, the center of the Oak Bluffs social scene, was nearby.

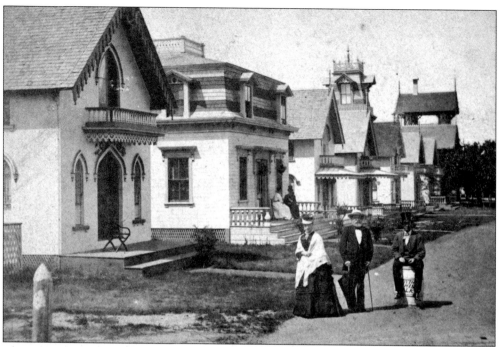

This view shows a row of cottages on the south side of Ocean Avenue. Rising above the trees, at the apex of Ocean Park, is the distinctive third-story pavilion on Harrison Tucker's cottage.

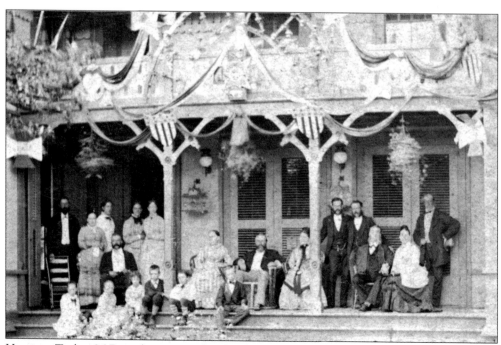

Harrison Tucker, M.D. and patent medicine manufacturer, was the resort's most noted resident. He loved to entertain and many notables visited his home.

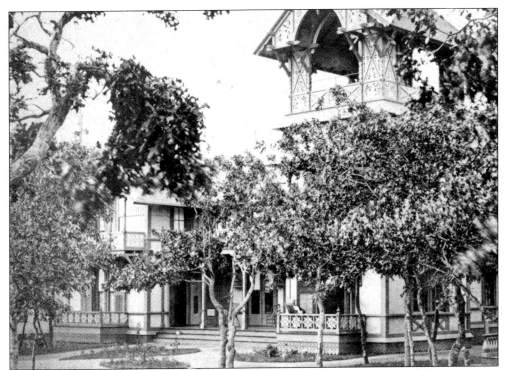

The Tucker cottage was one of the largest and most decorative cottages on Ocean Park. It was built at a cost of $11,000. The cottage consisted of three two-story sections. One of the sections had a third-story roofed pavilion with elaborate gingerbread trim. Pres. Ulysses S. Grant watched the fireworks in his honor from this pavilion in 1874.

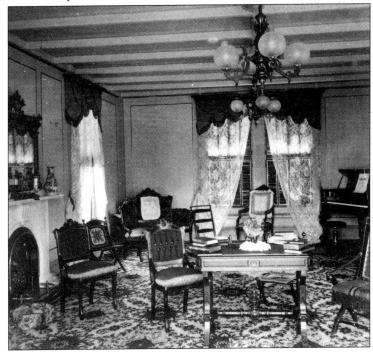

The parlor of the Tucker cottage was well furnished for entertaining. The cottage was equipped with a generator for 30 gas lights. Note the similarity in the post-and-beam framing to a campground cottage.

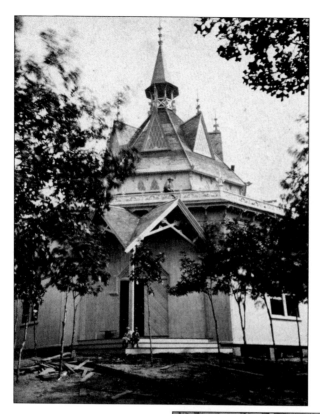

This view depicts the Union Chapel nearing completion in 1871. This distinctive building was octagonal in shape with a three-tiered roof. An octagonal spire rose to a height of 96 feet above the ground. On four of the eight sides were entrances. A three-story bell tower was later installed over one of the entrances.

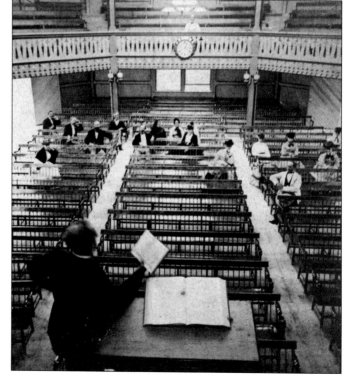

The Union Chapel was established as an interdenominational church for the resort community. The chapel could hold 800 people, and it was known for its fine acoustics. Meetings were also held here during the community's secession movement in the late 1870s.

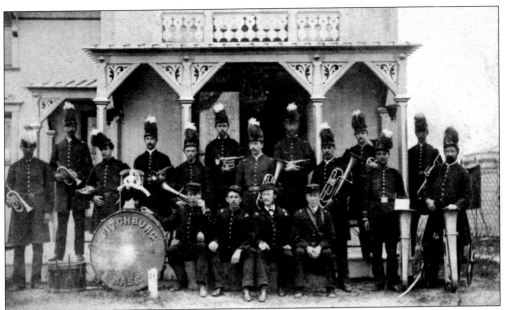

July and August were the months of excursions to Gay Head or Katama, dances, skating, boating, yacht races, and parades. Off-island bands, such as the Fitchburg band, played on the hotel balconies, at the bath arbor, and in parades lending a festive atmosphere to the resort.

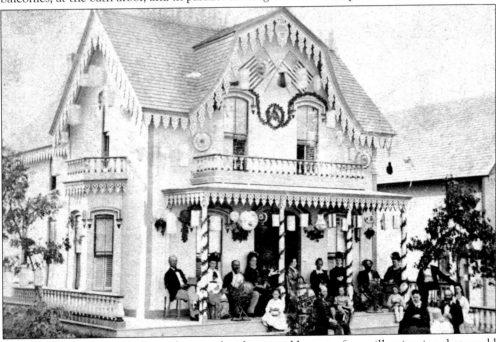

This cottage on Ocean Park was decorated with oriental lanterns for an illumination that would be held that evening. The first illumination was also held in Ocean Park as a celebration of the new Oak Bluffs resort. It occurred on the Saturday evening preceding the 1869 camp meeting and was accompanied with fireworks and a band concert. Illumination proved to be so popular that it became an annual event for the entire community, but eventually was held only on the campgrounds.

Circuit Avenue bordered Wesleyan Grove and the Oak Bluffs development. The Circuit Avenue House, shown here in 1870, was located on the Wesleyan Grove side of the avenue. Note the lot markers and that Circuit Avenue is a narrow path.

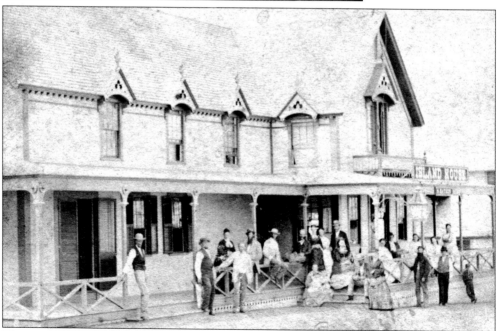

This view shows the Island House on Circuit Avenue around 1871. The storehouse, which had been built near the wharf, was removed and cut into two sections. It was reassembled, as the Island House, with the two sections at right angles to each other.

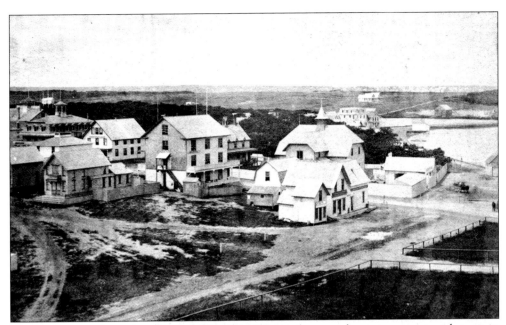

Circuit Avenue, shown here from the Sea View House, became the main commercial street in the Oak Bluffs development with shops, rooming houses, and large hotels. The Circuit Avenue House can be identified by its sign. The Island House is next to it. The road across Squash Meadow Pond, in the background, is Kedron Avenue. It provided access to the campgrounds from the Highlands wharf for the camp meeting participants.

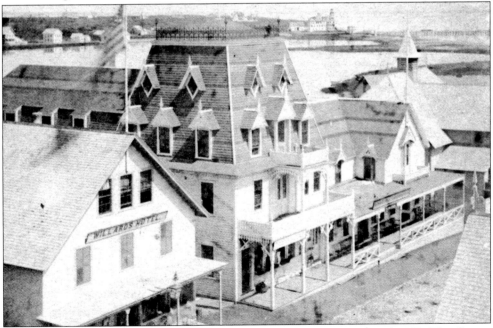

This view shows Circuit Avenue, as seen from the Pawnee House around 1875. The Circuit Avenue House had been renamed the Willards Hotel with George Willard as the proprietor. The Island House, which continued under proprietor Hiram Hayden, had expanded its lodging space.

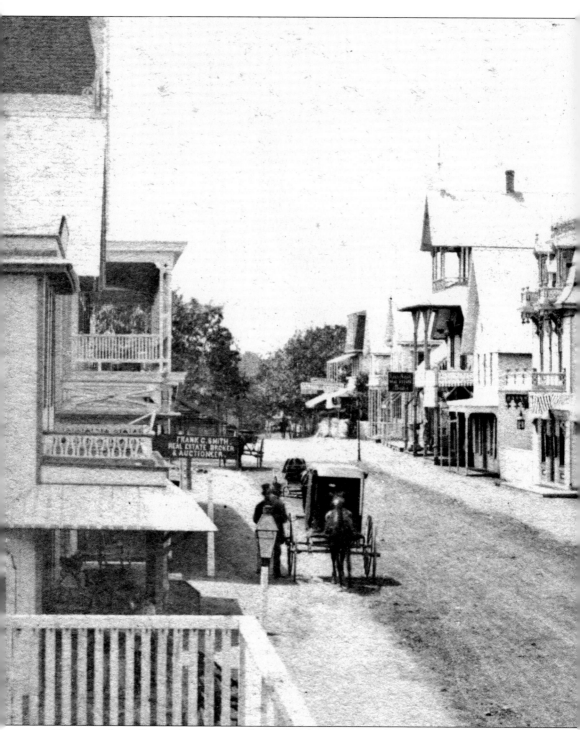

This view shows Circuit Avenue around 1877. On the campground side of the avenue were Taber's grocery store, Novelty Market, Arcade, Cleavland and Bradley grocery store, photography studio of Stephen Adams, shell shop of George Nickerson, Baxter House, Willards Hotel, and Island House. In 1869, the Camp Meeting Association had erected a picket fence in order to protect

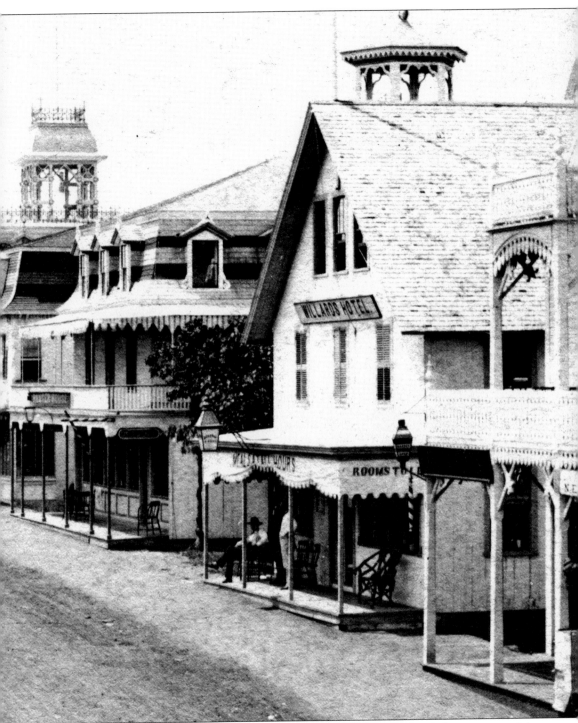

the camp meeting from the resort activities. The fence was located behind these commercial businesses and also along the entire boundary of their property. The gates into the campgrounds were locked at night.

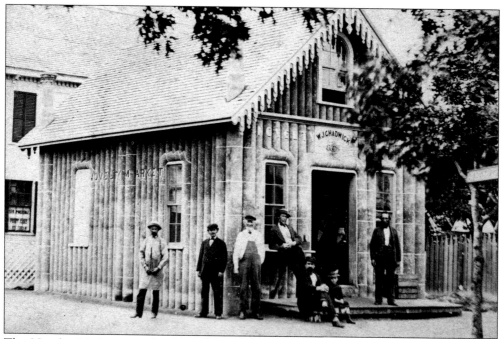

The Novelty Market, seen here in 1869, could readily be identified by its distinctive wall construction. A section of the picket fence, which separated the campgrounds from the Oak Bluffs resort, can be seen next to the market.

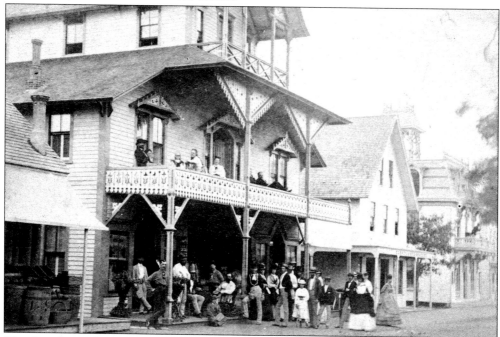

The Arcade was built in 1870 by the Oak Bluffs Land and Wharf Company. This impressive building was located between the Novelty Market and the Cleavland and Bradley grocery store. The Arcade had offices, shops, and lodging. It also served as the gateway from the Oak Bluffs resort to the campgrounds.

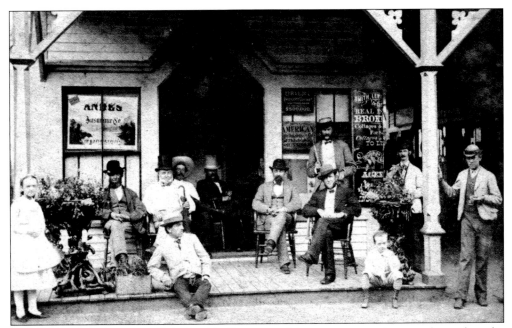

Lewis Smith's real estate office, *Seaside Gazette*, and insurance agencies were located at the Arcade in 1875. The *Seaside Gazette* was issued Tuesdays and Fridays during the season until camp meeting week, then every day for that week. Subscription price for the season was 50¢. Fire insurance was extremely important with so many wooden buildings in close proximity. It appears from the number of posters that it was also a highly competitive business.

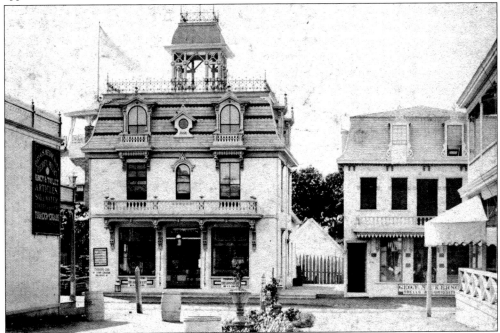

This view shows the photography studio of Stephen Adams and the shell shop of George Nickerson. Note the display board of stereoscopic views at the Adams studio and the section of the picket fence behind the buildings.

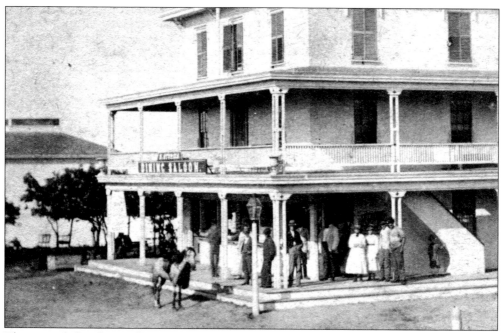

The young lady, who is riding side saddle, has stopped at the Pawnee House on Circuit Avenue. The Pawnee House was one of the first hotels in Oak Bluffs and it was well known for its fine accommodations. Many of its rooms had ocean views, which spanned from Cape Poge to Woods Hole.

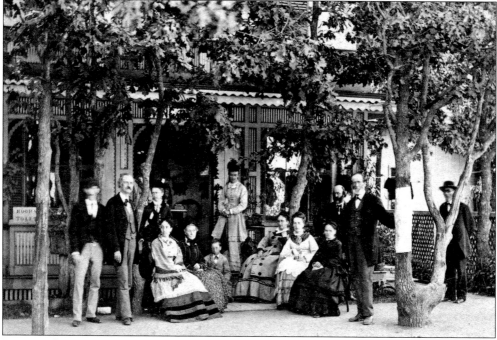

Rooming houses, such as the Vine Cottage on Circuit Avenue, were popular alternatives to the larger hotels. Lodging was especially scarce during the camp meeting weeks and many business establishments also rented rooms.

The Oak Bluffs wharf was a busy place in the 1870s. By 1875, there were as many as 20 steamers a day going into Oak Bluffs. The Martha's Vineyard Railroad, which started operation in 1874, ran from the wharf along the beach to Edgartown, and as far as Katama. The nine-mile ride from Oak Bluffs to Katama took approximately 30 minutes and cost 75¢. In 1876, a half-mile branch to South Beach was added to the line.

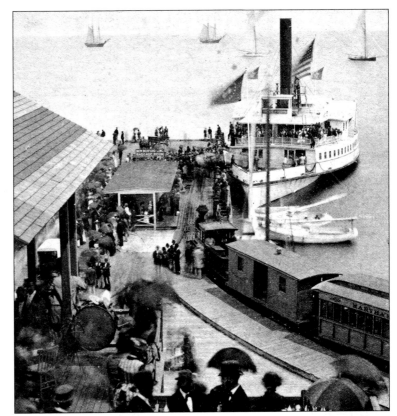

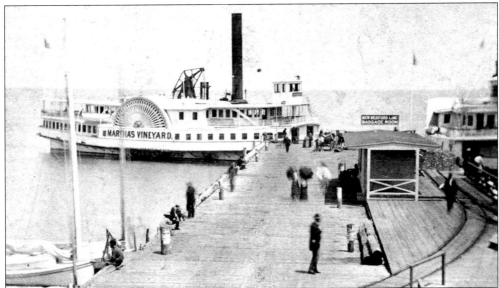

The steamers *River Queen* and *Island Home* operated from the wharf at Woods Hole. The steamers *Monohansett* and *Martha's Vineyard* operated from the wharf at New Bedford. The *Martha's Vineyard* was the fastest of the steamers and on one occasion made the run to New Bedford in 1 hour and 36 minutes. There were also many steamers, which were not affiliated with the island lines, and they were used to bring excursionists to the Oak Bluffs resort.

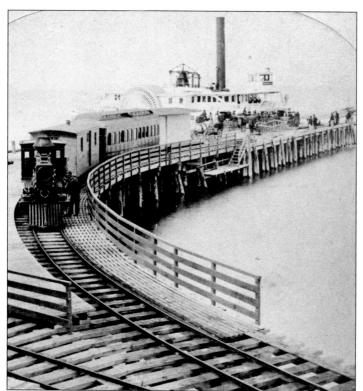

The Martha's Vineyard Railroad was a narrow-gauge steam railroad. The wye section of track on the wharf was used to turn the locomotive around. The locomotive was originally named *Active* by the builder. It was renamed *Edgartown* and later *South Beach*. A closed coach, shown here with the baggage car, was named *Oak Bluffs*. It had upholstered seats and a light. Another coach, which was open, was named *Katama*. It had curtains and unpadded seats. A third coach, similar to the *Oak Bluffs* coach, was delivered in 1877.

A travel brochure proclaimed, "Oak Bluffs, the Cottage City of America, is the most attractive watering-place in the world. It is unique, elegant and worth crossing continents to see."

Three

VINEYARD HIGHLANDS

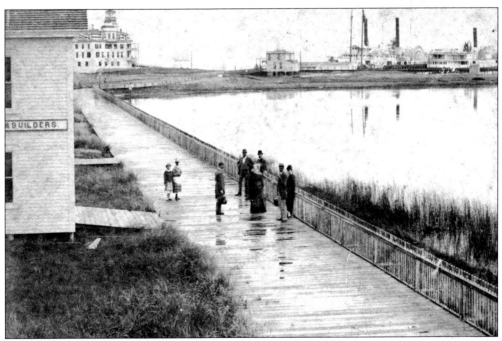

The Vineyard Highlands were laid out by the Vineyard Grove Company, with the thinking that the Methodists might have to move their camp meeting site from Wesleyan Grove due to the encroachment of the Oak Bluffs development. A new wharf and a large hotel, the Highland House, were built. A plank walk, and later a horse-drawn trolley line, connected the wharf to Wesleyan Grove.

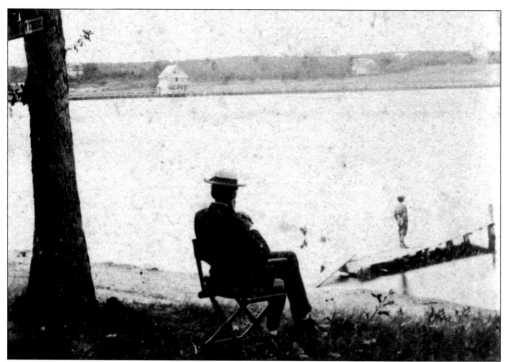

The Vineyard Grove Company, an organization that was closely aligned but separate from the Martha's Vineyard Camp Meeting Association at Wesleyan Grove, purchased about 300 acres of land on the opposite side of Squash Meadow Pond from the Wesleyan Grove site. Lots were sold to the public and a large oak grove was reserved for future religious services.

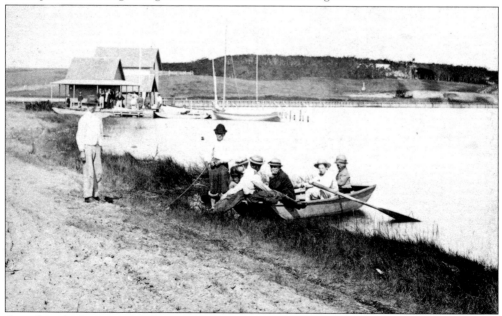

A road was built across Squash Meadow Pond in 1869. It allowed direct access from the Highlands wharf to the new campground entrance at Domestic Square. Near the entrance was a boat bazaar where boats could be rented.

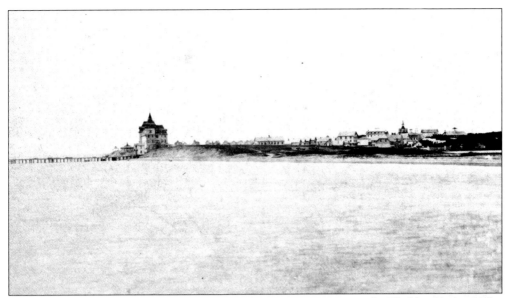

This is a view of Oak Bluffs, as seen by steamer passengers arriving at the Highlands wharf. The Highlands wharf was built as a more sedate alternative landing to the Oak Bluffs wharf with its festive atmosphere.

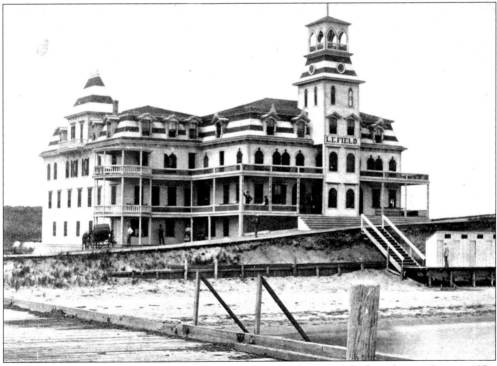

The Highland House, which was located near the wharf, opened for boarders on June 1, 1871. The mansard roof, then in the height of fashion, and the observation tower were its principal claims of distinction when it opened. A total of 300 guests could be accommodated after the side wing was later added. Advertisements emphasized that its location surpassed any hotel on the Vineyard and its ocean view was without a parallel on the coast.

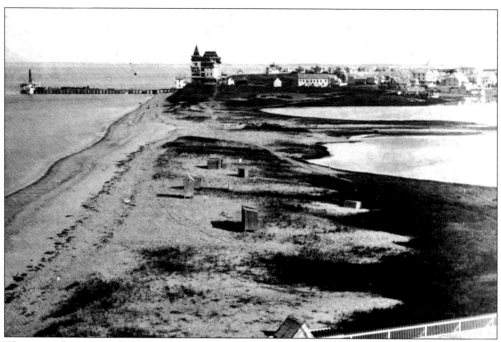

This view depicts the Oak Bluffs development as seen from the Highland House around 1872.

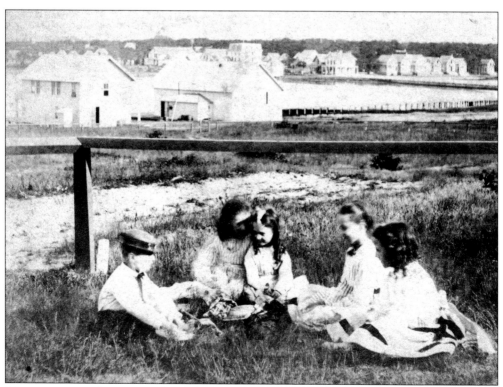

These youngsters have stopped on the Highlands for a few minutes rest. Note the pedestrian walkway and the campgrounds in the background.

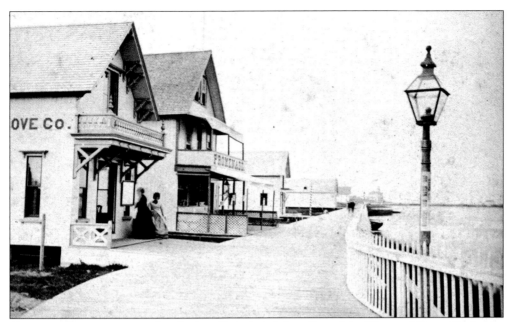

Commercial enterprises on the plank walk included the office of the Vineyard Grove Company, Promenade Hotel, Otis Foss's general store, Gregory's museum and shell shop, and Lander's house and sign painting company. Note the sign on the lamppost advertising for Warfield's cold-water soap.

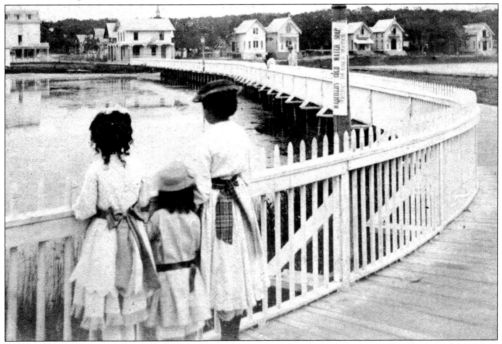

The road across Squash Meadow Pond was named Kedron Avenue, a biblical reference. After its construction, entering the campgrounds from this direction became known as "Crossing over Jordan." The section of Squash Meadow Pond north of the avenue was named Lake Anthony, and the section south of the avenue was named Meadow Lake, and was later renamed Sunset Lake.

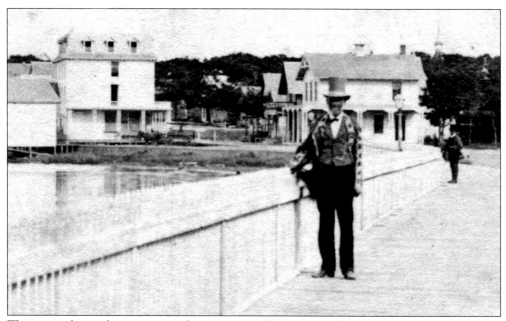

This view shows the campground entrance at Commonwealth Square, formerly known as Domestic Square, around 1878. On the left side of this view is the Howard House, and on the right side are the Hatch Express Office and Vineyard Grove Post Office.

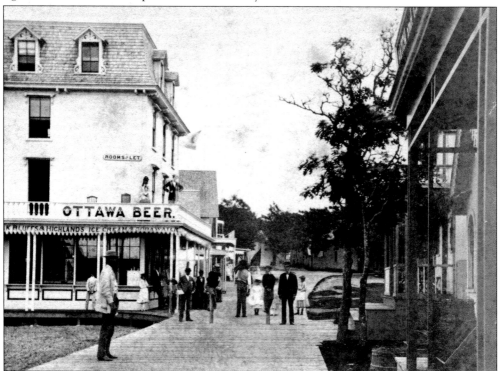

On the first floor of the Howard House was a restaurant that served refreshments, such as ice cream and soda water. The sign reads, "Ottawa Beer," but it was of a non-alcoholic variety on the campgrounds, where temperance was strictly enforced.

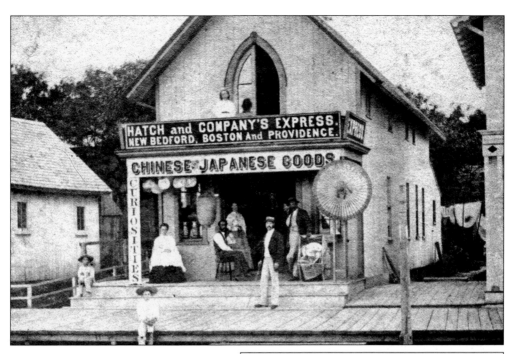

The community was growing in the 1870s with new real estate developments and an increasing number of visitors, summer residents, and permanent year-round residents. Baggage handlers had to contend with many changes in streets and developments. In addition, the community was also known by its postal designation, as Vineyard Grove. Steamer passengers arriving for the camp meeting were reminded that all baggage, by whatever route, should be checked for the Highlands wharf or Camp Meeting Landing, otherwise it would be carried to the other landing at some distance away, causing the owner much annoyance.

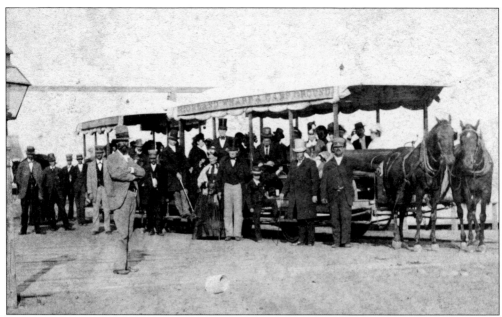

The Vineyard Grove Company installed the Vineyard Highlands Horse Railroad, a horse-drawn trolley with open cars, in 1873. The tracks ran from the Camp Meeting Landing at the Highlands wharf to the campgrounds.

Vineyard Highlands Horse Railroad.

On and after June 21st,

Passenger and Baggage Cars will run **Daily** on the Arrival and Departure of the New Bedford, Woods Hole and Nantucket Steamers, from Camp Meeting Landing, Highlands Wharf, to the Camp Ground.

Cars will run half-hourly and oftener if necessity requires, from Camp Ground to Hotel and Bathing Houses at the Highlands Wharf.

**FARE — Single Tickets, 6 Cents.
10 Tickets for 50 "
22 Tickets for $1.00**

Merchandise and Baggage will be delivered to and from the Boats to Camp Ground, Highlands, and all other localities at the lowest rates.

Try this route, especially if you have baggage, and you will soon discover that it is not only the most pleasant, but that it is attended with less expense. Baggage checked at the wharf.

All Baggage for Car transportation should be marked " Camp Meeting Landing," and Avenue or Park, when it can be landed at the nearest point available to them. No wharfage charged on personal baggage.

S. P. COFFIN, Supt.

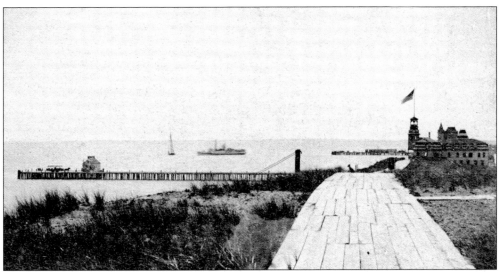

Steamers from the mainland would first disembark passengers at the Highlands wharf and then at the Oak Bluffs wharf, even though the two wharfs were only a few hundred yards apart. Note the trolley car awaiting passengers at the end of the Highlands wharf.

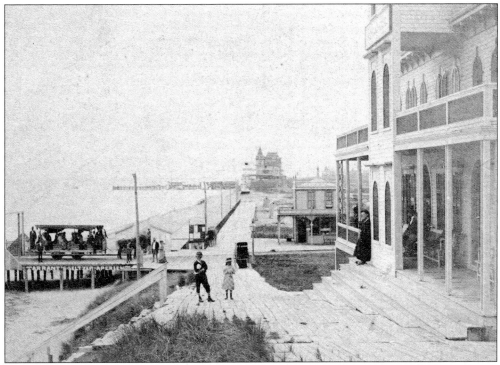

This photograph was taken from in front of the Highland House. It shows the horse-drawn trolley car and the waiting room near the wharf. The wagon of the photographer, Stephen F. Adams, can also be seen in this view. The wet plate had to be processed in his wagon within a few minutes or the photograph would have been ruined.

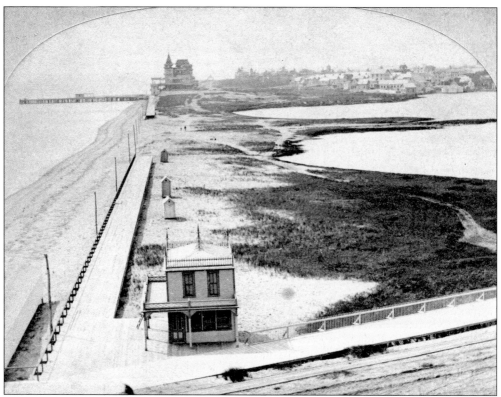

By 1877, the Oak Bluffs resort was not considered as bad as some people had originally thought, but note that the plank walk along the barrier beach is still missing a center section. People are instead taking a shortcut between the two developments on a well-worn sandy path.

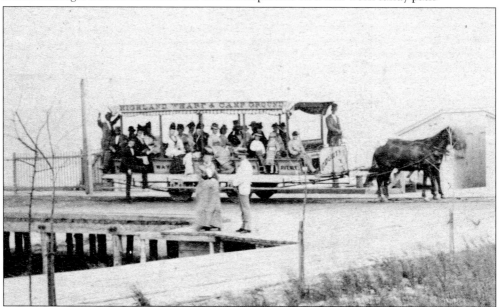

The No. 1 trolley car, named *County Park*, is ready to set out on its short trip to the campgrounds. Note that the trolley car is very well labeled for its single destination.

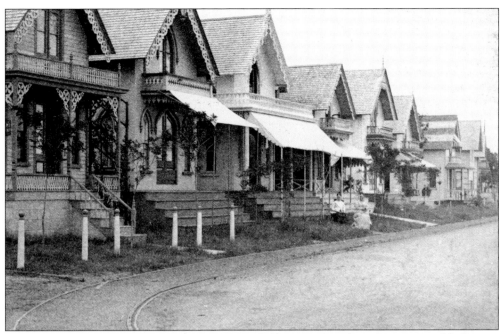

After "Crossing over Jordan," pedestrians entered the campgrounds at Commonwealth Square, but the trolley car turned onto Siloam Avenue. Further along, but on the opposite side of Siloam Avenue were Jonathan Cady's Providence House and Joseph Dias's Vineyard Grove House.

The Vineyard Grove House was open all year. It was recognized for its excellent accommodations. The dining room was also used as a meeting room by the year-round residents of the Vineyard Grove community. Religious classes were held here until the Methodist Chapel was built in 1878. Secession meetings were also held here prior to the incorporation of Cottage City in 1880.

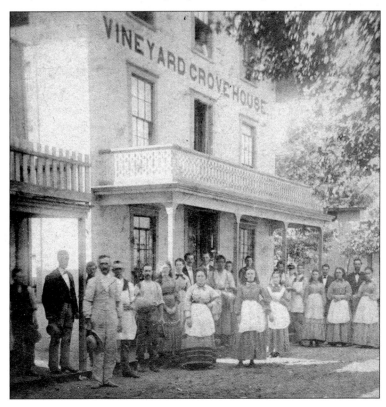

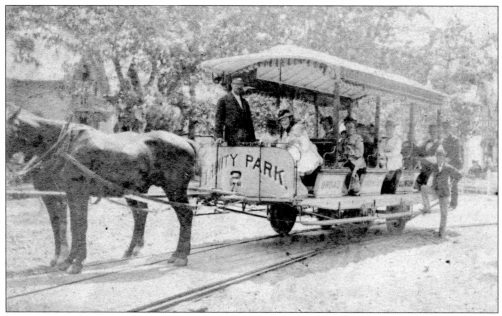

This view shows the No. 2 trolley car, named *Trinity Park*, at the intersection of Broadway and Clinton Avenue.

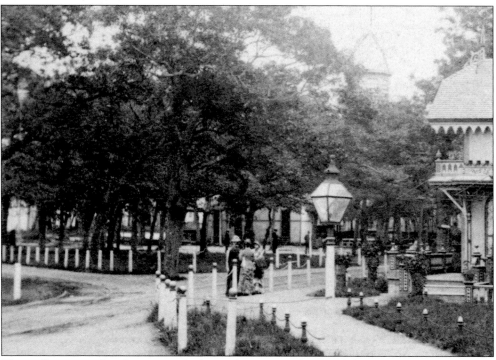

The trolley car made a loop around "the circle" on Broadway and then returned to the Camp Meeting Landing at the Highlands wharf. The Tabernacle can be seen in the background.

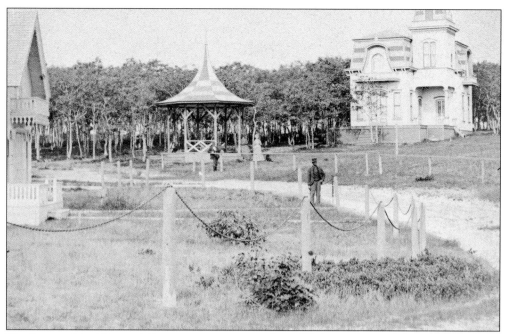

The layout of the Vineyard Grove property was similar to Wesleyan Grove. A large circular grove of trees had been reserved for the preaching area and it was made central to the development with parks located nearby, such as Wesley Park shown here.

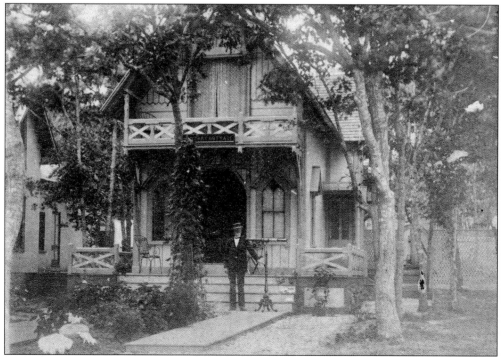

Mozart Cottage, the cottage of John D. King, was located on Dempster Park. King was a retired Methodist minister and the agent for the Vineyard Grove Company. He also taught microscopy at the Martha's Vineyard Summer Institute.

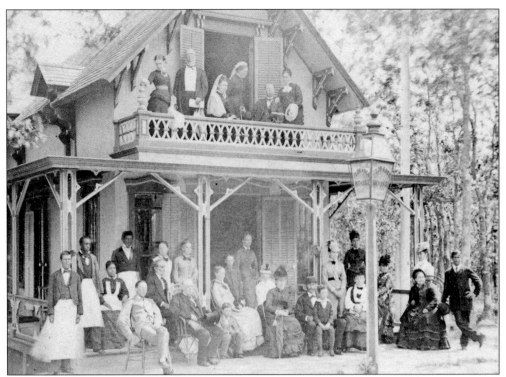

The boarding house of George Florance was located on Dempster Park. The Florance House was renamed the Temple House after the Baptist Temple was built.

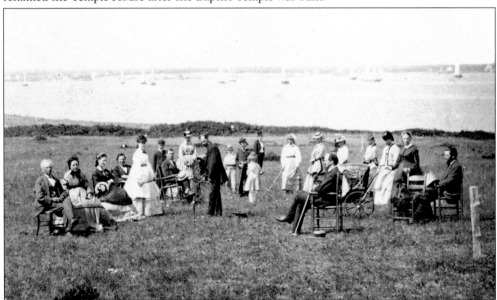

East Chop provided the best views possible of Vineyard Sound, Vineyard Haven and its harbor, and the mainland toward Cape Cod. Real estate speculators started new developments such as Bellevue Heights, Lagoon Heights, and Prospect Heights on East Chop in the early 1870s. However, the worst depression in the nation's history occurred in 1873, and all of the developments ended up losing money.

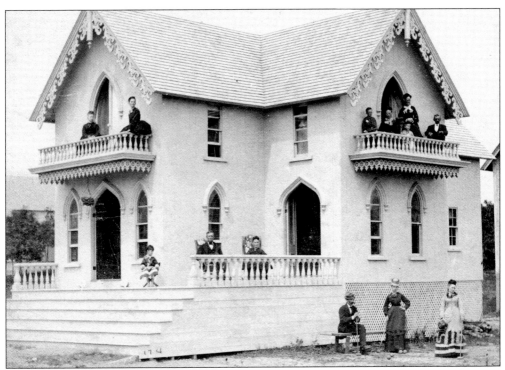

Cottages were arranged not only in the parks near Wayland Grove, but also in the other developments on East Chop. By 1880, there were over 90 residences in the Vineyard Highlands. The Bicknell cottage, shown here, was located on Kedron Avenue. The avenue had been extended to Eastville and a new wharf had been built to accommodate the Providence and New York steamers.

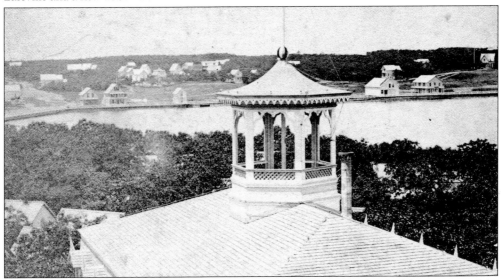

The Vineyard Grove Company sold their interest in the oak grove that had been reserved for future religious services to the Baptist Vineyard Association in 1875. The grove can be seen in the background in this view. Prior to that time, the Baptists had attended the Wesleyan Grove camp meetings, but they wanted to establish their own camp meeting. The first Baptist camp meeting was held in the same year at the grove site, now named Wayland Grove.

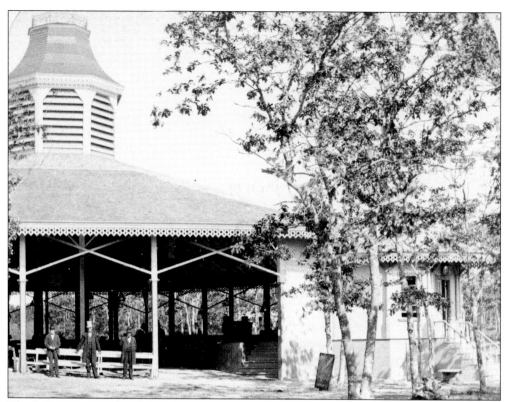

The Baptist Vineyard Association erected an octagon-shaped wooden temple on the Wayland Grove site. Dedicatory services for the temple were held on August 18, 1878, with 80 prominent ministers and 2,000 people in attendance.

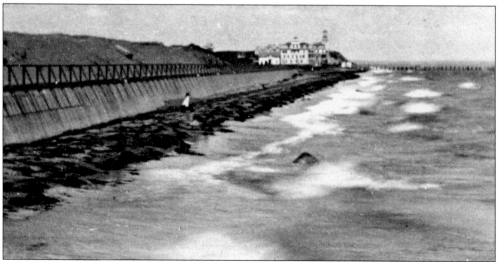

Two major religious camp meetings were now held on Martha's Vineyard. The preferred landing for both camp meetings was the Highlands wharf. The Martha's Vineyard Summer Institute, which was a summer school for teachers, had also been established in the Vineyard Highlands in 1878. Camp meetings, academic programs, and recreational activities were in place for the new town of Cottage City.

Four

COTTAGE CITY

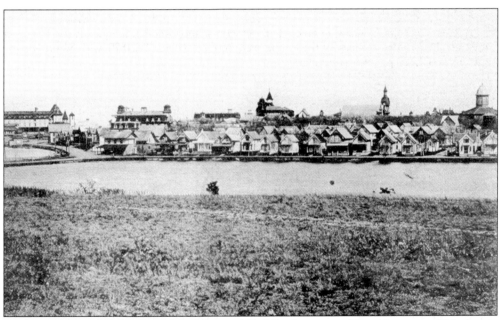

Wesleyan Grove, Oak Bluffs, and the Vineyard Highlands separated from the town of Edgartown in 1880 and a new town was formed under the name of Cottage City. An advertising brochure stated: "Cottage City, as its name signifies, is a city of cottages, with its avenues, hotels, churches, and places of amusement, and yet entirely unique in its character. From a famous camp meeting resort of many years, it has risen, as by the wand of enchantment, to a city, with many thousands of permanent summer residents and visitors."

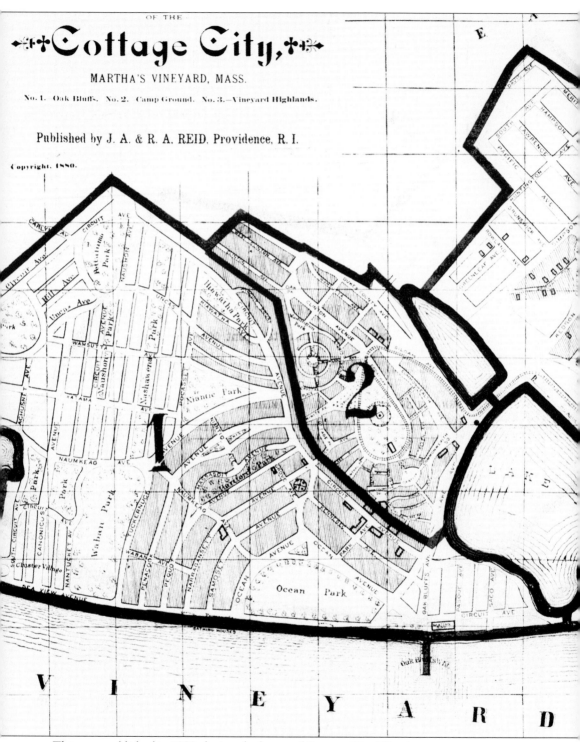

This map, published in 1880, depicts the layout of Cottage City. The three summer communities, which started with distinctly different secular and religious interests, have been blended into a single year-round community. The summer population was approximately 20,000 people in

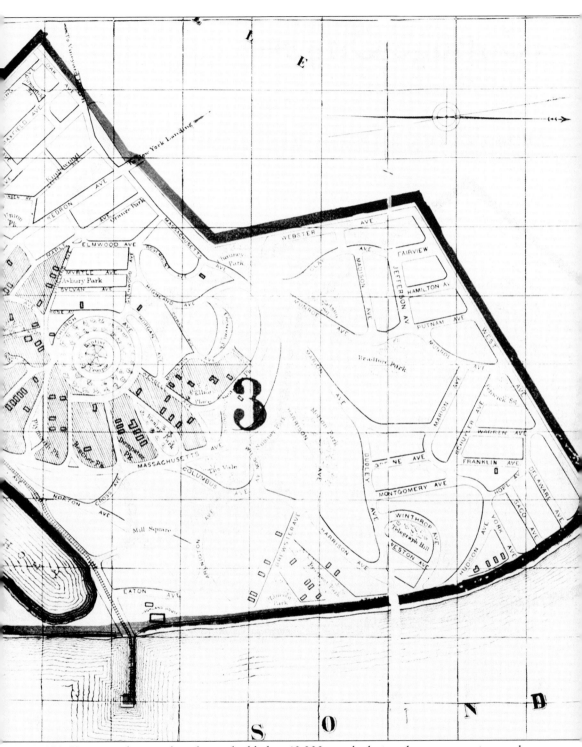

1880. However, that number almost doubled to 40,000 people during the camp meeting weeks. In the off season there were 570 year-round residents.

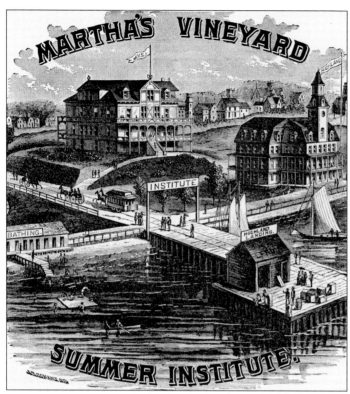

The Martha's Vineyard Summer Institute was established in the Vineyard Highlands for the purpose of affording teachers the opportunity of combining the study of some specialty with the rest and recreation of a seaside resort. The religious and moral tone of Cottage City was considered one of its chief advantages as a residence for the summer session.

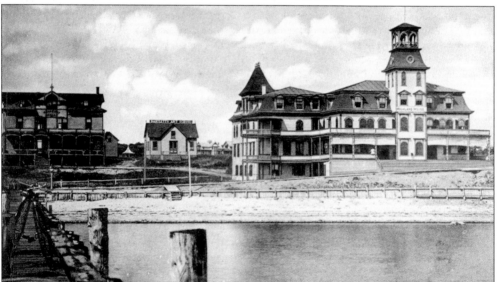

Agassiz Hall, the main building of the institute, and Bartlett's Art School were located a short distance behind the Highland House. Academic departments of the institute included botany, drawing, painting, elocution, oratory, English literature, geology, mineralogy, history, civil government, mathematics, microscopy, physical training, photography, and zoology. Foreign language classes were also taught as well as instrumental and vocal music lessons. By 1888, the institute had 1,500 students and 100 teachers and was recognized as the leading institution of this type.

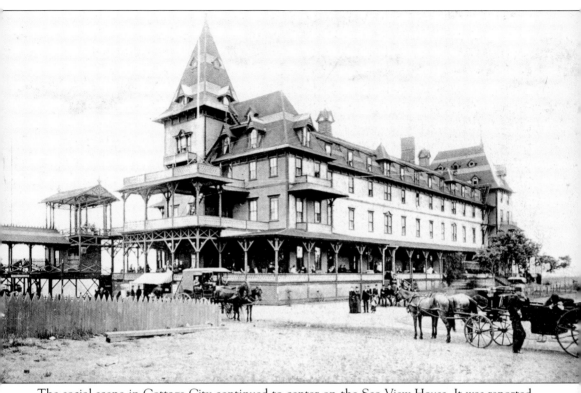

The social scene in Cottage City continued to center on the Sea View House. It was reported in the *Vineyard Gazette* on August 24, 1883: "The large dining room of the Sea View House was crowded to overflowing and many of the elite of Cottage City stepped lightly to the music of the Sea View band. The hall was so filled with dancers that a few young couples had to take to the piazza fronting the sea, where they had a dance all to themselves. On the west piazza, facing the City, hundreds came and went, looking in at the windows and wishing they were inside."

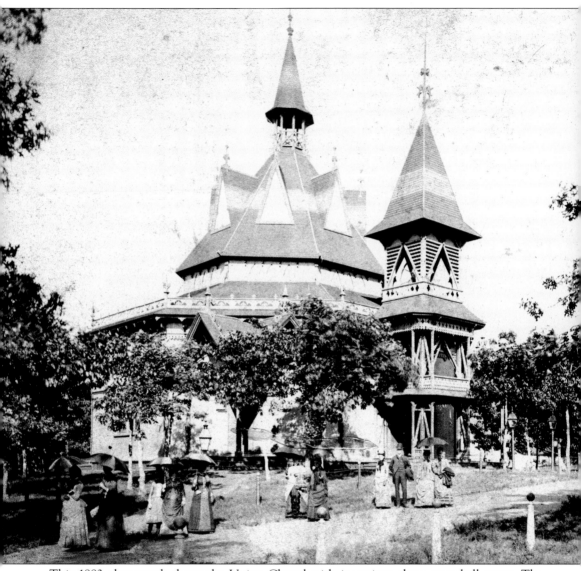

This 1883 photograph shows the Union Chapel with its unique three-story bell tower. The Oak Bluffs Christian Union had been organized in 1880 to maintain the Union Chapel as a non-sectarian place of worship. The Christian Union invited prominent clergymen of many denominations and continued to provide church music of exceptional quality.

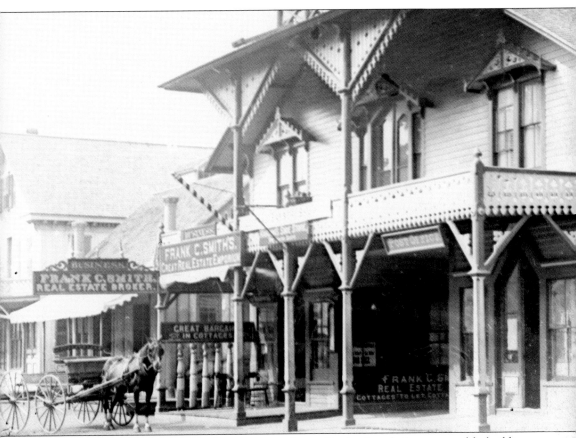

Frank C. Smith's Great Real Estate Emporium was located in the Arcade. It contracted for building, painting, repairing, and moving cottages. The Cottage City Post Office, also located in the Arcade, had two mail deliveries a day during the summer season and one after September 1. People mailing letters were reminded: "Letters intended for Vineyard Grove, Oak Bluffs, or Vineyard Highlands should be directed simply to Cottage City, Massachusetts."

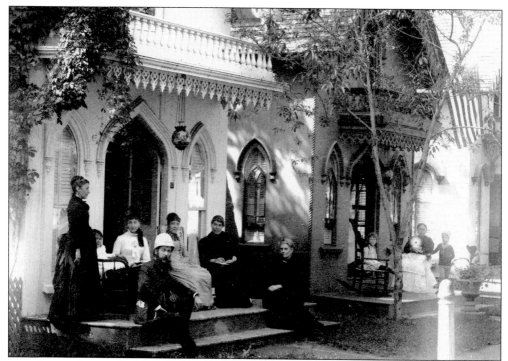

The cottage of the Damrell family was on Clinton Avenue. John Damrell was chief of the Boston Fire Department and was credited with stopping the fire in 1872 that had consumed 65 acres of downtown Boston. In 1883, the most destructive fire in island history destroyed over 60 buildings in Vineyard Haven. Damrell and the Cottage City volunteer firemen pulled their fire apparatus over three miles to help in the fire. Damrell later lobbied for the adoption of a unified national building code.

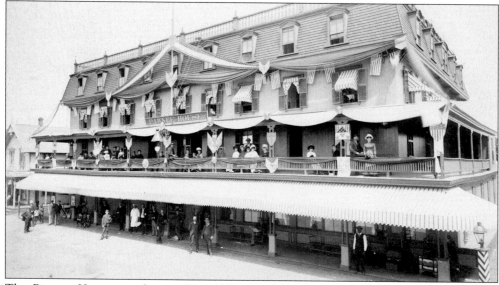

The Pawnee House was decorated in 1890 to celebrate the completion of the Oak Bluffs Waterworks. A water supply system had been built from Beech Grove Mineral Springs, which was located three miles away. Three days of celebration marked the memorable occasion.

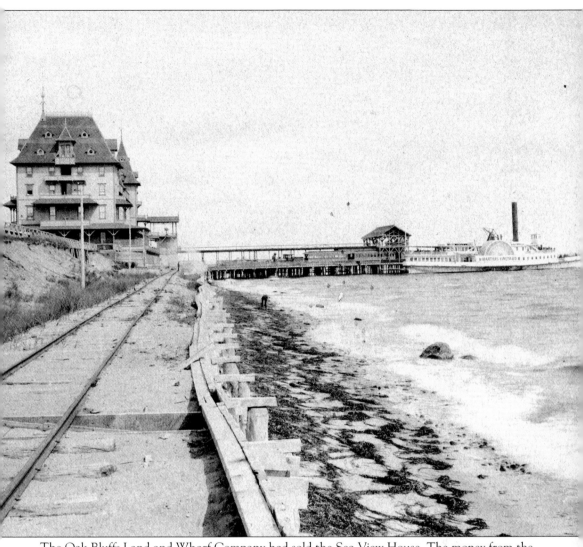

The Oak Bluffs Land and Wharf Company had sold the Sea View House. The money from the sale was used to improve the wharf. A two-story structure, 20 feet in width and extending to within 50 feet of the end of the wharf, was built. It had a highly ornamented enclosure on the front end, from which visitors could watch the arriving and departing steamers. Many people felt that the track for the Martha's Vineyard Railroad should have been laid out inland rather than along the beach. It turned out that they were correct, since storms repeatedly destroyed sections of the track.

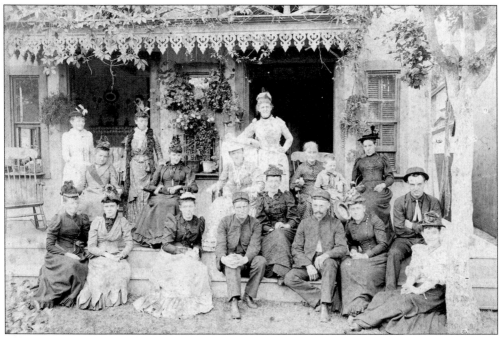

This photograph was taken in August 1891. Fashions had changed over the years, but these clothes still must have been very uncomfortable on a hot summer day.

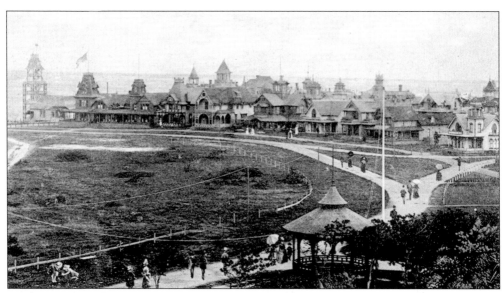

At the corner of Ocean Park, two cottages were combined to form a social clubhouse, called the Oak Bluffs Club. The building was used for receptions, banquets, dances, and the island headquarters of the New York Yacht Club. Its facilities included a banquet hall, ladies parlor, billiard room, and a card playing room for the gentlemen. Note the bandstand, which is located near the edge of the park.

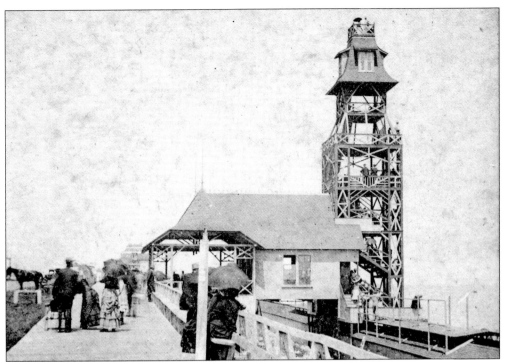

A 75-foot-high observation tower was added onto the bath arbor pavilion. It provided a spectacular view of Vineyard Sound, which was considered second only to the English Channel as the greatest thoroughfare for nautical vessels in the world. It was reported, that by daytime observation, more than 60,000 vessels passed by yearly.

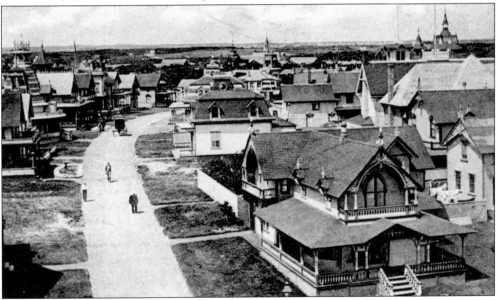

This view from the observation tower is looking inland along Narragansett Avenue around 1888. The spire and bell tower of the Union Chapel dominate the skyline. The decorative trim and towers on the cottages are still noticeable, but the major changes since the 1870s are the porches with roofs.

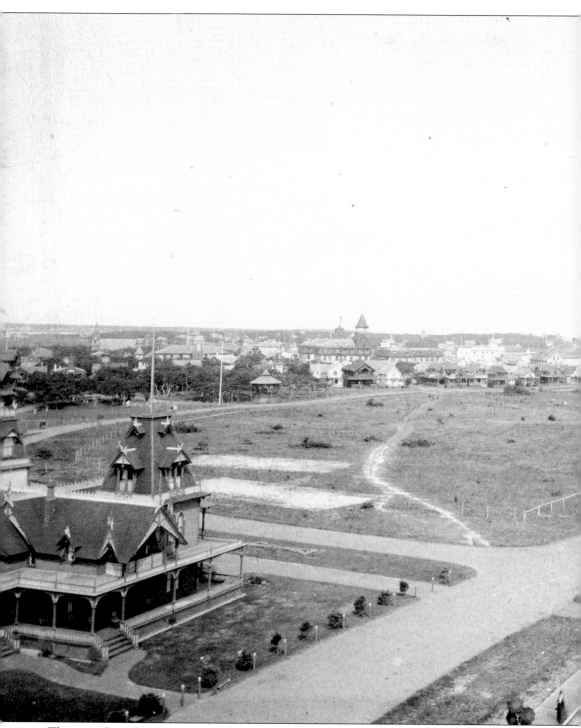

This view from the observation tower overlooks Ocean Park around 1888. It captures the Oak Bluffs Club, Tabernacle, Baptist Temple, Highland House, and Sea View House. East Chop and the mainland can be seen in the background. The pagoda refreshment stand has been

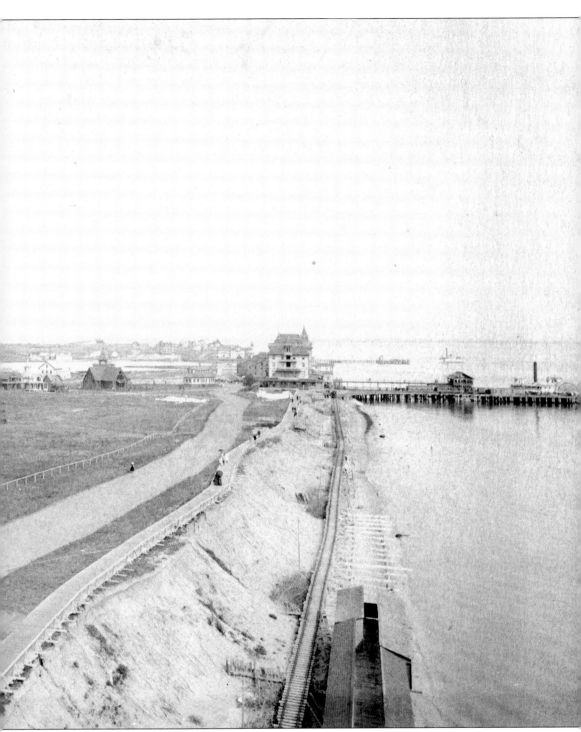

moved from the plank walk to a location near Lake Anthony. The north bluff has become an amusement area with the addition of the Vineyard Skating Rink in 1879, Flying Horses Carousel in 1884, and a wooden toboggan slide in 1887.

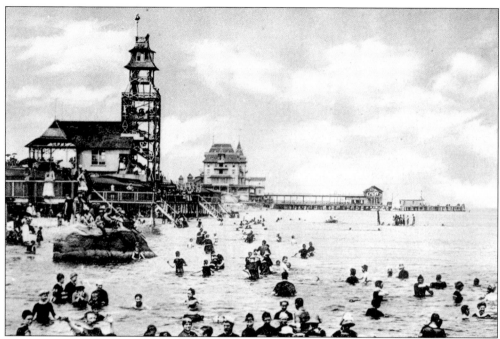

Many people are enjoying the beach on this summer day around 1888. The observation tower, gatehouse, skating rink, and Sea View House dominate the skyline.

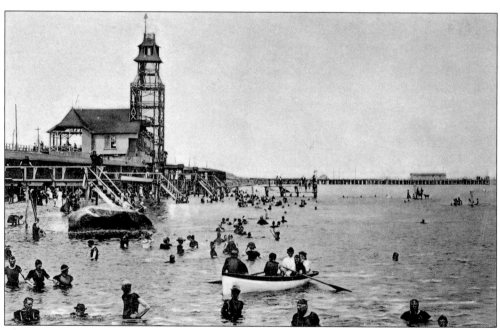

The Sea View House burned down during the night on September 24, 1892. The skating rink and the gatehouse were also destroyed in the fire. The wharf and the wye section of the railroad track were badly damaged. The fire was the first of several hotel fires, all of suspicious origin. The Highland House burned down in the following year.

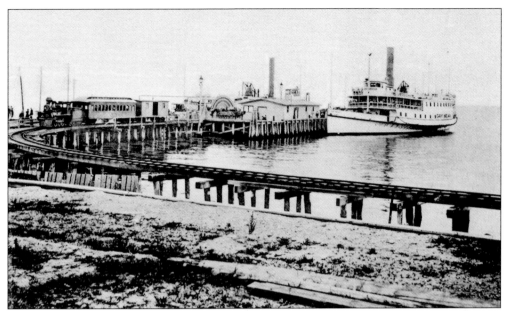

The Oak Bluffs wharf was repaired after the fire, but the charred ruins of the Sea View House now greeted the arriving steamer passengers. The wye section of the track was not replaced. From that time on, the locomotive pulled the coach cars from Cottage City to Edgartown, but it had to operate in reverse on the return trip. The Martha's Vineyard Railroad was never a financial success and it ran for the last time in 1895. The trestlework along the beach was left to decay for many years.

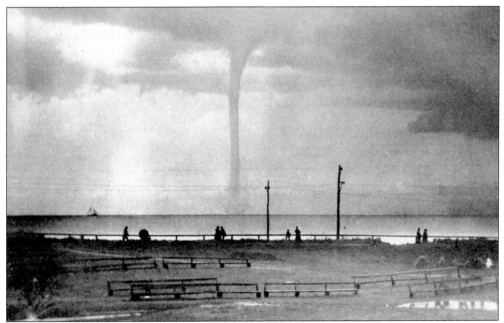

A rare meteorological event occurred off the shore of Cottage City on August 19, 1896. A giant waterspout from a thunderstorm formed and dissolved three times. The waterspout was largest on its second appearance, when it was vertical and formed a pillar 3,600 feet high.

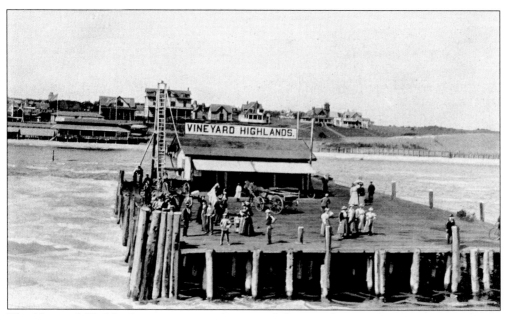

The Vineyard Highlands was an active section of Cottage City in the summer months. In mid-July, the Martha's Vineyard Summer Institute opened with a five-week session. Friday evenings were devoted to receptions of professors, students, and invited guests at Agassiz Hall. On Saturdays there were excursions to South Beach for a clambake or to Gay Head to inspect the cliffs. At the close of the institute session the annual meeting of the Baptists was held for a week followed by the annual meeting of the Methodists the next week.

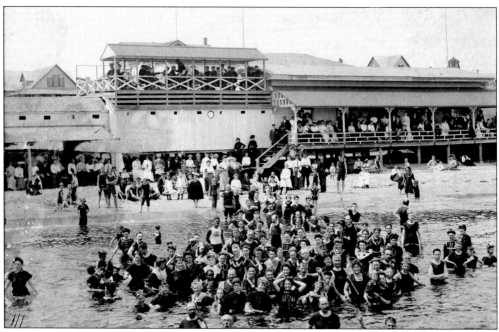

The Highlands beach was conveniently located near the wharf. It was a popular place for camp meeting and institute attendees on a hot summer day. The beach eventually had 200 bathhouses and a band concert was also held at their pavilion in the morning.

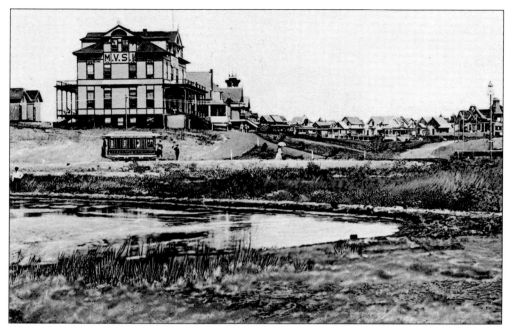

An electric trolley car, Agassiz Hall, and Lake Anthony can be seen in this view. The horse railroad had been replaced by an electric railroad in 1895. Additional rail lines were added to other sections of Cottage City and to Vineyard Haven. The Martha's Vineyard Summer Institute had become the largest institution for summer instruction of teachers in the United States. However, it could not compete with the summer programs of colleges and universities that gave course credits and it closed in 1906.

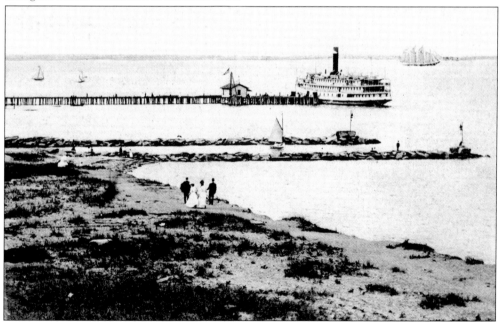

Lake Anthony was opened to the sea in 1900. Jetties were added at its entrance. A pollution problem was eliminated and Cottage City was provided with a fine new harbor. However, it also eliminated the shortcut between the Oak Bluffs development and the Vineyard Highlands.

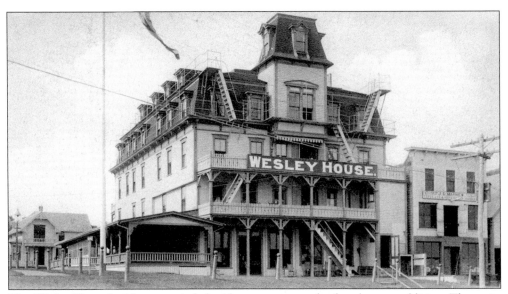

The Wesley House had been upgraded with two towers and a fourth-story addition. The main entrance, which was on the Commonwealth Square side of the building, was moved to the Lake Avenue side, overlooking the new harbor.

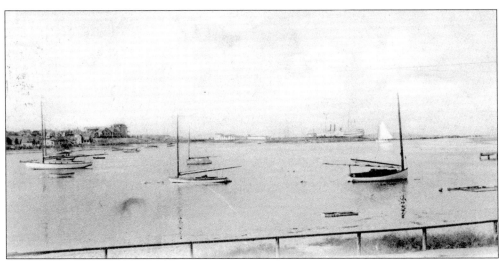

The photograph on this 1905 postcard was taken from the front porch of the Wesley House. It shows a steamer docked at the Highlands wharf. There are only a few boats in the new harbor. It was called Little Harbor, but it continued for many years to be known as Lake Anthony.

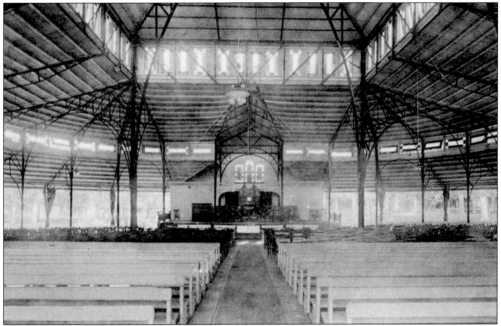

The interior of the Tabernacle is shown in this view around 1907. Stained-glass windows have been added behind the stage and a few rows of benches have been replaced with chairs. Major structural repairs were performed in 1901. It was stated in the annual report: "It is to be hoped that the thorough repairs and improvements will preserve it for a long time for the uses and purposes for which it was erected."

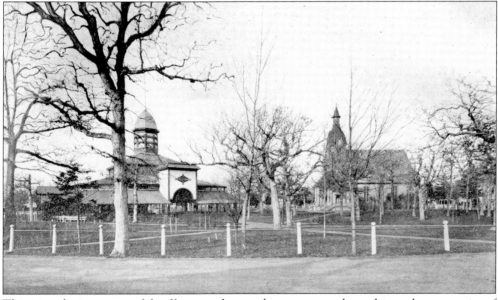

This view depicts a peaceful, off-season day on the campgrounds, and it evokes memories of another time when the horse-drawn trolley had circled this preaching area. The Tabernacle is located where a preachers' stand made from driftwood once stood. The Methodist Chapel was erected on the site of the society tents. The last society tent had been removed in 1883, but there was at least one family tent still remaining on Fourth Street in 1907.

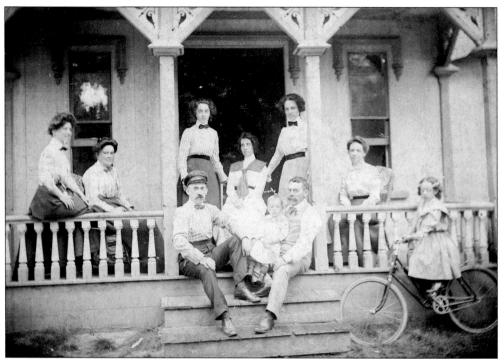

This family is relaxing on their front porch in 1900. A few of the cottages had porches with roofs in the 1870s, but the majority of the porches were added in the 1880s and early 1890s. The front porch allowed the parlor to be visually open, but functionally private, and the community atmosphere was still maintained.

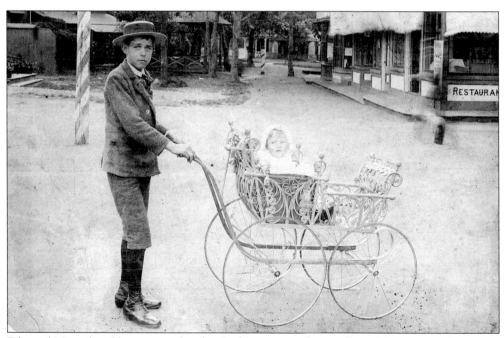

Edmond Merciel and his younger brother Ingham are out for a walk on Montgomery Square.

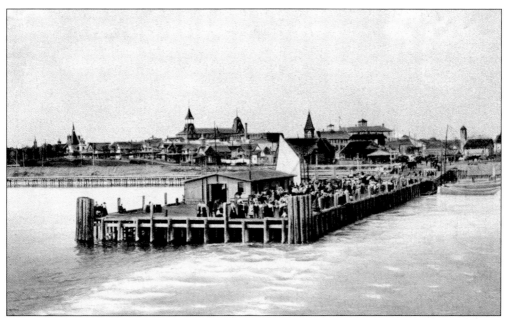

The grand entrance at Oak Bluffs, with the Sea View House and the gatehouse, is gone, but the skyline with its cottages on Ocean Park, its church steeples, and its hotels on Circuit Avenue still results in excitement on arrival.

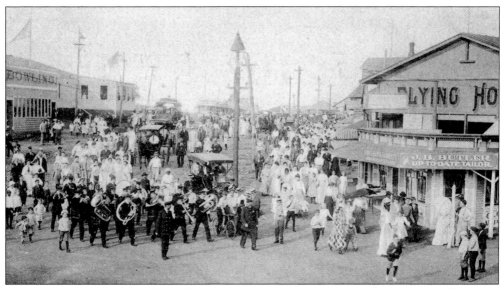

The band has just arrived off the boat and is about to parade up Circuit Avenue. The Flying Horses Carousel originally operated at Coney Island. It was relocated to Cottage City in 1884 and installed behind the skating rink on the north bluff. It was moved to the location shown in this view in 1889.

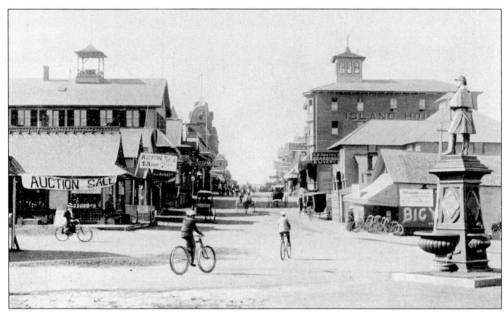

In the early 1900s, bicycles and horse-drawn carriages were the popular modes of transportation. The Island House continued to be one of the most popular hotels in Cottage City. It was regularly upgraded through the years. The Civil War fountain, shown in the foreground, was dedicated in 1891.

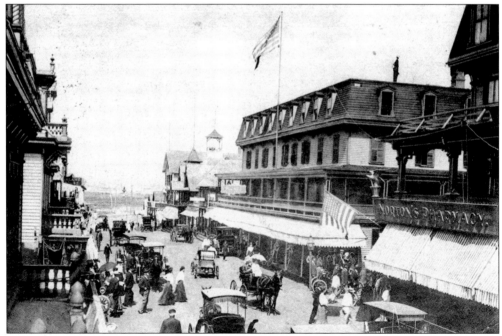

This view shows Circuit Avenue around 1907. Horse-drawn carriages now share the avenue with horseless carriages. The Pawnee House had been upgraded with the latest conveniences including double mattresses, gas lighting, and electric bells. The Pawnee House had also added an annex, the Metropolitan House. It featured a suite of rooms for families, Norton's pharmacy, and Rausch's ice-cream parlor.

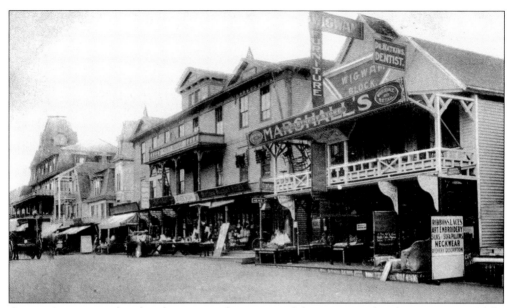

Circuit Avenue was lined with souvenir shops. Two of the most popular shops were Marshall's Wigwam and the Stchi Ban shop, shown on the left with the vertical white sign. Chinaware pitchers and plates were among the favorite souvenirs. They were imported from Austria and Germany and usually had transfer pictures of local scenes, such as Ocean Park or the Tabernacle, or the words "Souvenir of Cottage City" in gold lettering.

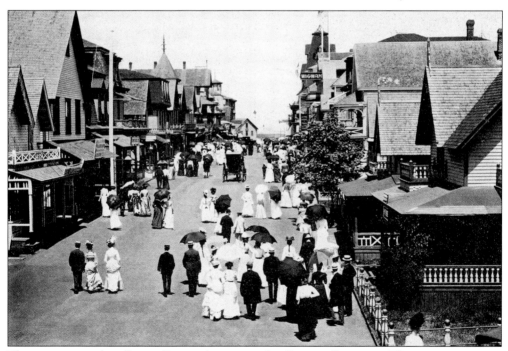

There were no sidewalks on Circuit Avenue in the Cottage City years. The entire street was a promenade. The remark was often made that Circuit Avenue looked like the midway of the Columbian Exposition, but on a smaller scale.

121

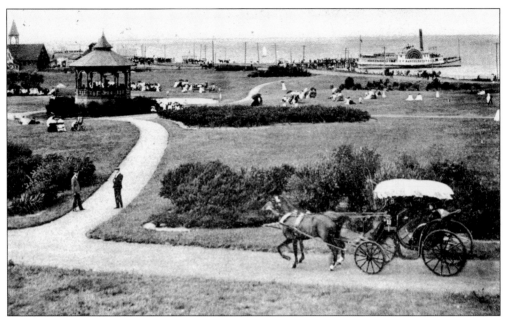

Ocean Park, the premier site in the Oak Bluffs development had not changed much since the 1870s. There was still a magnificent view from the park. Note that the bandstand had been moved to a more central location. Visitors could now gather around and listen to a band concert.

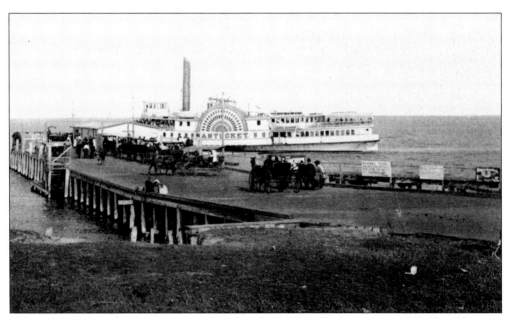

The steamer *Nantucket* has just arrived at the wharf. The Martha's Vineyard Railroad has not run for years, but the train trestle still remains. It was used as a stand for advertising billboards.

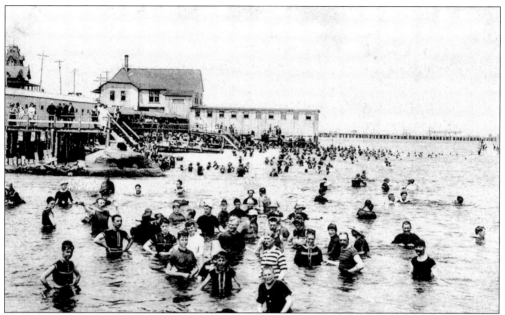

This postcard shows the Oak Bluffs beach. The observation tower had been removed in 1895. Beach recreation now included not only ocean bathing, but also swimming. The bathhouse, shown in the background, was originally constructed with a second story. The nearby residents complained that it destroyed their view. A court order had it lowered to the level of the bluff in 1902.

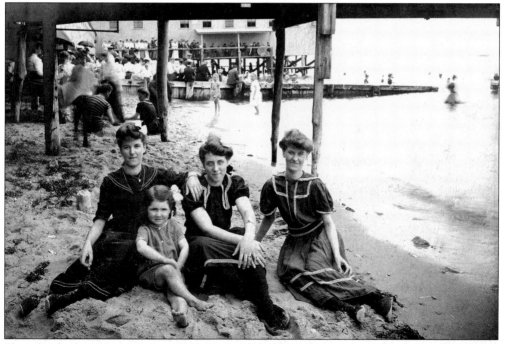

Sleeveless bathing suits were acceptable by the early 1900s. However, stockings were still required, at least on the adults. In the 1870s, bathers had changed very quickly out of their wool bathing suits, but now they could enjoy sun bathing on the beach.

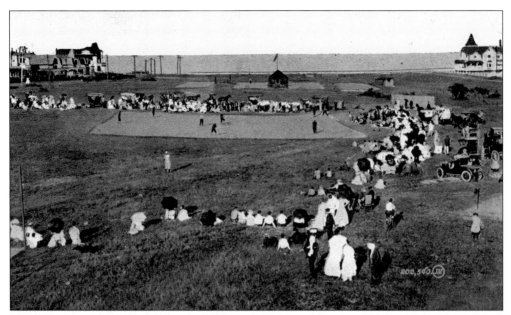

This 1903 postcard shows the baseball field and the roque courts on Waban Park. The baseball teams were from Cape Cod and the islands. Ball players were college students, who worked for the summer at the hotels that sponsored the teams.

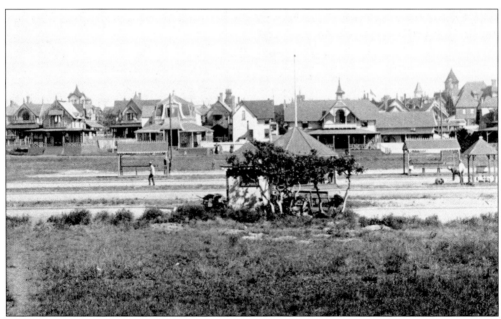

Roque was a variation on the game of croquet. It was played with a short handled mallet on a smooth clay court. The court was framed with planks, which allowed the ball to be caromed, as in billiards.

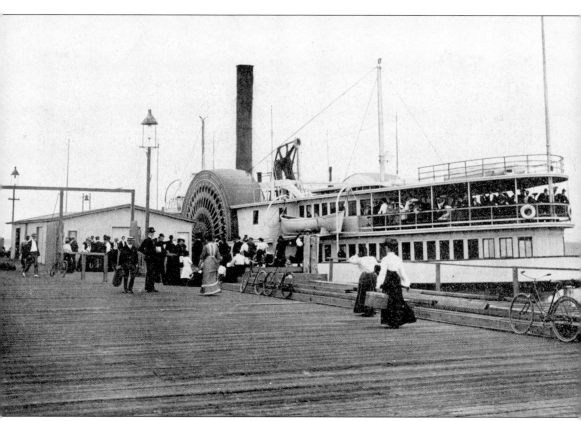

Another summer season comes to an end, and it is time to catch the last boat out from Cottage City. Later in the winter months, as they view the photographs and postcards, they will count the days to when they can return.

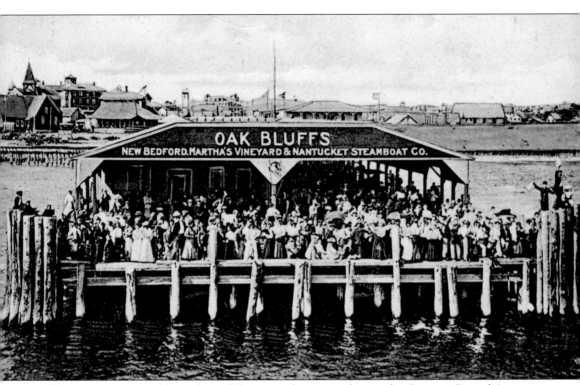

The town's name had been derived from an advertising slogan: the Cottage City of America. Since Cottage City was not really a city, many people felt that the name did not convey a true impression of either the town or of the beauty of the sea and the fine groves. The town was renamed Oak Bluffs in 1907.

BIBLIOGRAPHY

Dagnall, Sally W. *Martha's Vineyard Camp Meeting Association. 1835–1985*. Oak Bluffs, MA: Martha's Vineyard Camp Meeting Association, 1984.

Denison, Frederic. *Illustrated New Bedford, Martha's Vineyard and Nantucket*. Providence, RI: Reid Publishers, 1880.

The Excursionist: An Illustrated Guide to Martha's Vineyard, Nantucket and New Bedford. Providence, RI: Reid Publishers, 1886.

Hough, Henry B. *Martha's Vineyard Summer Resort*. Rutland, VT: The Tuttle Publishing Company, 1936.

LeBaron, Ira W. *The Campmeeting at Martha's Vineyard*. Oak Bluffs, MA: self-published, 1958.

Lobeck, A, K. *Brief History of Martha's Vineyard Camp-Meeting Association*. Oak Bluffs, MA: Martha's Vineyard Camp Meeting Association, 1956.

Morris, Paul C. and Joseph F. Morin. *The Island Steamers*. Nantucket, MA: Nantucket Nautical Publishers, 1977.

Page, Herman. *The Martha's Vineyard Railroad, 1874–1895*. The Dukes County Intelligencer, Vol. 37, No. 2, 1995.

Peck, William E. and Edward R. Stanley. *Directory of Oak Bluffs and the Camp Ground*. New Bedford, MA: self-published, 1875.

Railton, Arthur, R. *The History of Martha's Vineyard: How We Got to Where We Are*. Beverly, MA: Commonwealth Editions published in association with the Martha's Vineyard Historical Society, 2006.

Stoddard, Chris. *A Centennial History of Cottage City*. Oak Bluffs, MA: Oak Bluffs Historical Commission, 1980.

Vincent, Hebron. *History of the Wesleyan Grove Camp Meeting Held There in 1835 to That of 1858*. Boston, MA: George C. Rand and Avery, 1858.

———. *A History of the Camp Meeting and Grounds at Wesleyan Grove, Martha's Vineyard for the Eleven Years Ending With the Meeting of 1869*. Boston, MA: Lee and Shepard, 1870.

Weiss, Ellen. *City in the Woods: The Life and Design of an American Camp Meeting on Martha's Vineyard*. Second Edition. Boston, MA: Northeastern University Press, 1998.

Across America, People are Discovering Something Wonderful. *Their Heritage.*

Arcadia Publishing is the leading local history publisher in the United States. With more than 3,000 titles in print and hundreds of new titles released every year, Arcadia has extensive specialized experience chronicling the history of communities and celebrating America's hidden stories, bringing to life the people, places, and events from the past. To discover the history of other communities across the nation, please visit:

www.arcadiapublishing.com

Customized search tools allow you to find regional history books about the town where you grew up, the cities where your friends and family live, the town where your parents met, or even that retirement spot you've been dreaming about.